THE THAMES LOCKS

The author was born and educated in London. At first he was involved in diagnostic medical physics at two London teaching hospitals, but later his interests moved to British art and particularly the work of a number of Scottish artists. Following a period in Edinburgh he moved to an area of Gloucestershire within easy reach of the upper Thames.

Also by John Kemplay

The Two Companions: the Story of Two Scottish Artists

The Paintings of John Duncan: A Scottish Symbolist
Pomegranate Artbooks - San Francisco

THE

THAMES LOCKS

by

John Kemplay

———••◀∞▶••———

RONALD CROWHURST

Gloucestershire

Published by
Ronald Crowhurst and Co
5 West End Terrace
Chipping Campden
Gloucestershire

First Published 2000

ISBN 0 9518964 1 5

British Library Cataloguing-in-Publication Data

A catalogue record for this book is
available from the British Library

Printed by Graham Printing Co., 47 Thistle Street, Edinburgh

For

Malcolm W S R Lewis

with whom I first
discovered the Thames

CONTENTS

ILLUSTRATIONS

Between pages 18-19

Fourteen maps of the river between
Inglesham and Teddington

Between pages 50-51

The Thames at Inglesham 1996
Old Windsor lock prior to reconstruction in 1953/54
One of the tail gates of Old Windsor lock during reconstruction 1954
Four stages in the reconstruction of Cookham lock 1956/57
Sandford lock in the final stage of reconstruction 1973
Excavation of Marlow lock 1927
A Salter's steamer in Boulter's lock 1957
Tail wall of the derelict lock in the Swift Ditch 1998

PREFACE AND ACKNOWLEDGMENTS

The history and the construction of the Thames locks is a neglected subject and were it not for the diligent research by F. S. Thacker, which resulted in two volumes, *The Thames Highway*, volume I - General History, London 1914, and volume II - Locks and Weirs, Surrey 1920, little would be known about the way the locks transformed the Thames into the navigable waterway we know today. Following the publication of Thacker's second volume in 1920 a number of changes in the management and construction of the Thames locks took place. As lock-keeping became more demanding the keepers engaged in an uphill struggle with the Thames Conservancy for better wages and conditions of work; and following the Second World War there were major advances in lock design and construction. Even though Thacker was most assiduous in compiling his two volumes, there are indications that he did not have access to all the material held by some of the administrations responsible for building the Thames locks. In addition, there are instances when Thacker gives dates that appear to be in error. Hence, in this short history of the locks I have blended some of Thacker's research with material from official records in order to give a broad outline of the development of the river as a navigable waterway from the time the first locks were built.

The administrations were the Oxford-Burcot Commissions, the Thames Navigation Commissioners, the City of London Corporation and the Thames Conservancy. The records of the Oxford-Burcot Commissions are held in the Oxford University Archives, while copies of the records of the City of London Corporation Thames Navigation Committee are held at the Corporation of London Records Office; the records of the Thames Navigation Commissioners and the Thames Conservancy are held in the Berkshire Record Office. To complement these records there are the reports by the engineers who advised the Thames Navigation Commissioners; these are held in the library of the Institution of Civil Engineers.

When I first undertook to write this book I was fortunate to be given much helpful advice by T. R. Christie who at that time was Navigation Secretary at the National Rivers Authority (now the Environment Agency). He also kindly arranged for me to see uncatalogued material that had been recently deposited with the Berkshire Record Office. I should also like to thank others at the Environment Agency: Dennis Boreham, J. M. Redmond

and John Waters; but most particularly I should like to thank Rowland Raynor for his continued support throughout this project and allowing me to see engineering plans for locks under reconstruction. And not least I should like to thank John Powell for his comments and Stephen Capel-Davies for his advice on engineering aspects of lock design and construction. I am also indebted to Jake Kavanagh for allowing me to use his cutaway drawing of a Thames lock, and Anne, my wife for compiling the index to this book.

John Kemplay
December 1999

CHRONOLOGY

1630-1635 The first locks are built by the Oxford-Burcot Commissions. They are sited below the City of Oxford at Iffley, Sandford and in the head of the Swift Ditch.

1772-1773 The first series of locks is built between Sonning and Maidenhead by the Thames Navigation Commissioners. The series comprises: Sonning, Shiplake, Marsh, Hambleden, Hurley, Temple, Marlow and Boulter's.

1778-1789 The second series of locks is built between Dorchester and Reading by the Thames Navigation Commissioners. The series comprises: Day's, Benson, Cleeve, Goring, Whitchurch, Mapledurham and Caversham.

1790-1791 The third series of locks is built between Lechlade and Oxford by the Thames Navigation Commissioners. The series comprises: St John's, Buscot, Rushy, Pinkhill, Godstow and Osney. In addition, though not part of the series, Abingdon lock was built in 1790.

1798-1810 Two further locks are built by the Thames Navigation Commissioners: Culham and Romney.

1811-1815 The fourth series of locks is built between Staines and Teddington by the City of London Corporation. The series comprises: Penton Hook, Chertsey, Shepperton, Sunbury, Molesey and Teddington.

1817-1845 A further seven locks are built between Abingdon and Staines by the Thames Navigation Commissioners. Clifton, Chalmore Hole, Cookham, Bray, Boveney, Old Windsor and Bell Weir.

1892-1898 Grafton, Radcot, Shifford and Northmoor locks are built between Lechlade and Oxford by the Thames Conservancy.

1927/28 Eynsham and King's locks are built by the Thames Conservancy.

1

THE EARLY RIVER

In the eleventh century, Edward the Confessor made a proclamation concerning navigation on the four Royal Rivers.[1] In effect, the proclamation stated that mills, fisheries and other works that might hinder navigation should be destroyed. Clearly, it was intended that navigation should have precedence over other uses of the rivers. A century later, in 1197, Richard I vested the care of the river Thames in the Mayor and Corporation of the City of London and commanded that weirs and other obstacles on the river be removed as they were an intolerable impediment to navigation. It would appear that his command and that of Edward before him were ignored, as in 1215 a clause in Magna Carta decreed that 'all weirs . . . shall be utterly put down by Thames and Medway, and through all England . . .' And yet the mill-owners and fishermen who had built the weirs had done so for a very good reason, for flour and fish formed an essential part of the diet of the people living in the towns and villages alongside the river as well as further afield. Hence, the fisheries, and the weirs serving the mills, were still to be found on the river in the fourteenth century when an Act (Edward III) stated that the Thames and other great rivers of England were obstructed by weirs and kiddles.[2] There followed various Acts to improve navigation on the river Thames by removing the obstructions, but they obstinately remained.

It may appear that various kings and their advisers failed to see that the Thames presented a declivity of twenty inches to the mile and with such a fall, the future of navigation on the river would be achieved only by

1. Thames, Severn, Trent and Yorkshire Ouse.
2. A kiddle is a barrier with openings fitted with nets and placed in the river to catch fish.

breaking the river up into stretches and making each stretch of sufficient depth of water to enable barges and other vessels to operate without grounding. To a great extent the mill-owners were already creating this situation, though mainly for their own ends. The weirs they built created the necessary water power to drive the mill wheels and brought about a more stable depth of water upstream of each mill. The fundamentals of a navigable river were therefore in place and all that was necessary was a well thought out plan of development. But such a plan was not so easily constructed owing to the interests of a number of parties of whom a few held the key to the future.

Before the first locks were built on the Thames in the early part of the seventeenth century, the river was the concern of three parties whose individual interests conflicted. The mill-owners had built weirs across the river in order to raise and maintain the level of the river for the continuous operation of their mills; bargemasters required a passage through these weirs in order to transport goods up and down the river and in doing so altered the levels of the river to the aggravation of the millers; and riparian land-owners were at the mercy of these altercations that often led to their lands becoming flooded. The weirs the mill-owners built had an opening for navigation purposes and they were called flash-weirs. The opening was normally closed by a series of paddles held in position at the top of the weir by a wooden beam and supported throughout their length in the water by rymers, each rymer locating with a wooden sill or rymer plate on the bed of the river.[1] The bargemaster would negotiate his passage through the weir by arrangement with the miller, who would draw the paddles allowing water from the upper level of the river to flow quickly into the lower level until the levels began to equalise and the flow of water was much reduced. The barge would pass downstream with the flow of water through the opening in the weir, but in the upstream direction, that is against the stream, it was usual to winch the barge through the opening. Following the passage of the barge the paddles were replaced and the river above the weir would begin to rise to its previous level. On occasions when a barge became stranded in shallows below a weir, the bargemaster again had to negotiate with the miller to open the paddles in his weir in order to pass more water downstream to refloat the barge. This practice created a flush or flash of water and was often the only way of enabling barges to

1. Rymers are wooden posts which hold the paddles in position and locate them with the rymer plate. When the paddles are withdrawn, the beam and rymers are moved aside to make an opening in the weir. The rymers were necessary so that the weir-keeper could withdraw or replace the paddles against the pressure of the stream.

navigate in times of short water.

In order to satisfy the three parties it became evident that a system for controlling the water was essential if the mills were to continue running while at the same time allowing barge traffic to navigate freely, and not least, the levels of the river be maintained in such a way that riverside lands did not become flooded. It was the introduction of the lock in the form of a chamber with pairs of mitre gates at each end that formed the basis of the locks on the Thames today and brought about the necessary improvements to the river, while at the same time more or less satisfying all the parties. What is important is that the lock in passing a vessel used very little water, whereas a flash-weir wasted a huge volume of water as it was necessary to lower the level of the river above the weir to roughly the level below in order to allow a vessel to pass through the navigation opening. But the introduction of the lock was a slow and costly process and it took 300 years to complete the changes and improvements that were necessary to create a navigable waterway between Cricklade in Wiltshire and the tidal part of the river.

THE WORK OF THE ADMINISTRATIONS

During the period of time taken to make the Thames a navigable waterway a number of administrations were involved and it was the purpose of the earlier administrations to build locks and weirs, dredge the river bed, make towing paths for the horses that pulled the barges, and collect tolls from the barges that passed through the locks. The earliest administration was the Oxford-Burcot Commission formed in 1605 to make improvements to a particularly bad stretch of the river between Oxford and Burcot. Later, in 1751, the Thames Navigation Commissioners were formed to carry out improvements to the navigable state of the river from Cricklade to Staines, and later still the City of London Corporation, who had in theory more than in practice exercised their jurisdiction over the whole navigable river since 1197, made improvements between Staines and Teddington. But it was not until the formation of the Thames Conservancy in 1857 that the work done by the earlier administrations was brought together and completed in a way that made the river into the navigable waterway we know today.

The work of the Thames Conservancy during its period of administration was of considerable importance. The Conservancy made improvements to navigation on the river at a time of rapid progress in mechanical and civil engineering. The simple mechanical devices used in the

construction of early locks and weirs were developed to a degree that by the early nineteen-seventies the Conservancy was introducing new methods of engineering that would not have been conceivable fifty years earlier. An additional aspect of the work of the Conservancy was concerned with water purification and land drainage, and as a result of the Land Drainage Act of 1930 the additional discharge of water into the Thames from the many tributaries initiated the Thames Improvement Scheme, a scheme that brought about the deepening and widening of the channel between Shepperton and Teddington to increase the discharge of water over Teddington weir and thereby lessen the possibility of flooding.

The achievements of the Conservancy ended on 1 April 1974 when the Water Act of 1973 brought about the establishment of water authorities on a regional basis, of which the Thames Water Authority took the place of the Conservancy. While this created a change in the administration of the river, in effect it made little or no difference to the way engineering projects to improve navigation were carried out. Neither did the Water Act of 1989, which repealed much of the Water Act of 1973, and provided for the establishment and function of a National Rivers Authority with committees to advise that Authority and to provide for the transfer of property, rights and liabilities of the existing water authorities to the new Authority. Hardly had the Water Act of 1989 become established when the Water Resources Act of 1991 consolidated the enactments relating to the National Rivers Authority, which continued as a corporate body.

When the first locks were built on the river more than 350 years ago it was the beginning of an uneasy relationship between the commissioners appointed to reform the river and the owners of the many flash-weirs in whose best interest it was to control water levels and the passage of river traffic. Mill-owners needed to control water levels in order to provide a head of water to drive their mills, while riparian owners would build kiddles to catch fish. With the introduction of the first locks on the river the purpose was to improve navigation, and though the long term plan was to replace the many flash-weirs that presented an impediment to river traffic, it was essential that weirs continued to be used as a part of the restructuring of the river. Weirs are necessary in order to maintain and control the level of water upstream of each lock, while the locks replaced the need for the navigation opening that was part of each flash-weir. The pattern for the future was therefore a lock with a weir nearby to control the water level above the lock. If it had been as simple as this during the administration of the Thames Navigation Commissioners, the Thames may have attained its full potential as a highway for commercial traffic and established itself in

this respect before the advent of the railways. But it was not a simple matter because of the tenacity of the owners of old flash-weirs to keep their weirs and extract tolls from passing traffic. Hence, the smooth operation of the river was hindered by these obstructions and though the owners may not have thought of them in this light, this is precisely what they were.

The battle to remove the flash-weirs was a long one, and it was because of this that the river failed as a major highway for commercial traffic during the latter eighteenth century and into the nineteenth century. The struggle was particularly bitter in the reaches of the river above Oxford, where many flash-weirs existed at the time the Thames Commissioners were attempting to improve this section of the river in order to accommodate the additional barge traffic created by the opening of the Thames and Severn canal in 1789. Not only did the flash-weirs impede river traffic passing between the locks constructed by the Commissioners, they also caused difficulties in maintaining water levels owing to the method of their operation.

When the Thames Conservancy gained full administrative powers on the river in 1866, it was not in a position to remove all the flash-weirs, even though they continued to be a hindrance to river traffic. In fact it was not until the early twentieth century that the Conservancy made moves to rid the river of the remaining flash-weirs between Lechlade and Oxford. During the latter nineteen-twenties the flash-weirs immediately above Oxford at King's and Eynsham were made redundant by the construction of new locks, and Medley weir was removed altogether, leaving only one flash-weir on the river, and that was Eaton or Hart's upper weir near Kelmscot, three and a half river miles below Lechlade. It was not until 1937 that Eaton weir was removed, freeing the river entirely of flash-weirs for the first time.

The scene was then set for the river to operate in the way it was intended, employing only locks to convey river traffic from one section of the river to the next. This happened at a time when Great Britain was about to become engaged in a second World War and for a time there was an increase in commercial traffic on the river. In later years commercial traffic declined sharply as road haulage became the preferred method of transporting goods, and the river was left to cater almost entirely for pleasure traffic. It was at this stage that the Thames Conservancy, now nearing the end of its period of administration, brought about the beginning of a new era in lock construction and water control to accommodate the increase in pleasure traffic, and these advances were continued by the Thames Water Authority, the National Rivers Authority and most recently the Environment Agency.

THE LOCKS DURING THE PERIOD OF THE OXFORD-BURCOT
COMMISSIONS
(THE OXFORD COMMISSIONERS)

In 1605 special legislation was enacted to improve a stretch of the Thames below the City of Oxford. At that time the river was navigable from London to Burcot, the latter some fourteen miles downstream of Oxford. Over the years, barges of increased size required a greater depth of water in order to navigate the length of the river and the stretch between Oxford and Burcot had gained the reputation of being impassable (Map 4). The removal of various impediments and obstructions was all that was needed to facilitate the passage of boats and barges as far as Oxford and beyond, and with this in mind the Recorder of Gloucestershire in a communication to the Vice-Chancellor of the University of Oxford, conveyed his belief in certain schemes proposed by James Jessop for making the river more navigable. The Act (James I) of 1605 was, however, vague in its terms and notably omitted to give the necessary powers to the commission it created, to build locks. The commission, which comprised the Vice-Chancellor of the University, the Mayor of Oxford and about ten others, held its first meeting in 1607 and resolved to divide itself into three groups for the purpose of surveying sections of the river from Clifton ferry near Burcot, to Cricklade in Wiltshire. Following the survey the commission agreed that while the river above Oxford was navigable, the stretch below Oxford as far as Burcot needed attention. Navigation was frustrated by shoals between Sandford and Nuneham Courtney and at Abingdon, extensive obstructions at Sutton Courtney, and a rock bed with half sunken ledges at Clifton Hampden. Nothing further happened and the Act of 1605 was repealed in 1623 in favour of a new Act (James I) giving more specific powers to improve the river between Oxford and Burcot. The need to improve this unnavigable

stretch of the river had become increasingly essential and would be to the good of Oxford: first, the conveyancing of Headington stone to London would be easier and secondly, the movement of coal to Oxford would be improved. The new Act, passed in 1624, gave powers to the eight elected commissioners, four from the City of Oxford and four from the University, to make the river from Oxford to Burcot navigable by building locks and weirs, providing winches to assist with hauling barges upstream and preparing a towing path that would not be a hindrance to any person.

Although the newly elected Oxford-Burcot Commission (hereinafter called the Oxford Commissioners) appeared to act promptly by carrying out a survey for the necessary improvements, and the University ordered in 1626 that a bequest by Sir Nicholas Kempe should be used to fund the project, a period of seven years slipped past with little to show for the Commissioners' earlier intentions. In 1631, Charles I, who appeared to have more interest in the functioning of the river than his predecessor, ordered a body of men he had appointed a year earlier to deal with navigation on the river below Staines, to look at what the Commissioners were attempting to do. It is likely the findings showed that although the Commissioners did not act to make the necessary addition of locks on the river in the early part of their administration, they did bring about some improvement to navigation between Oxford and Burcot. But it was the construction of a lock at Iffley, Sandford and the Swift Ditch that brough about the major improvement to navigation.

In the absence of official records, a reference in *Thame Isis* by John Taylor indicates that Iffley and Sandford locks existed at the time of publication of his book in 1632, and it is the only indication they were built before that year. Notwithstanding the actual year the locks were built, it is recorded that the first barge reached the City of Oxford on 31 August 1635, even though it is doubtful that all the necessary dredging and clearing of impediments had been completed, as it was not until 2 August 1638 that the Oxford Commissioners were congratulated upon bringing their undertaking to a 'happy' conclusion.

The work undertaken by the Oxford Commissioners is of historic importance. Not only were the locks they built the first on the river, but a means of gaining revenue from them was established. The manner in which the Commissioners obtained revenue from 1638 onwards was to place their works under a responsible management. In effect, an agent or manager rented the works comprising the three locks between Oxford and Burcot, and a wharf. As part of the agreement the manager would erect a crane on the wharf at Oxford where St Aldates crosses the river and rebuild or repair the existing weir in the Swift Ditch near Culham bridge. Any of these works

requiring repairs at a later date would be paid for by the Commissioners subject to the cost of a repair being more than one twelfth of the annual rent of the works.

Although the lock at Iffley and the lock at Sandford are still in use today, though not in their original form, it is unlikely that the lock in the Swift Ditch was used later than 1790. The history of the Swift Ditch is particularly interesting for although it had become an almost unknown feature of the topography of the river by the early twentieth century, it was referred to as the 'chefe Streme' before the eleventh century and the only navigable channel of the river in the vicinity of Abingdon. At some time between 955 and 963 a channel from the main stream was cut to the Abbey and in 1060 a further channel was made to join with the Swift Ditch where it now passes under Culham bridge. But this is not an indication that the Swift Ditch was abandoned after 1060, as there is some evidence that it was still in use about fifty years before the Oxford Commissioners formally re-opened it in 1624. The lock was built about 1635 and again the Swift Ditch became the main navigation channel. This state of affairs lasted until a lock was built at Abingdon in 1790 and the Swift Ditch was finally abandoned as a means of navigation.

At the time the Oxford Commissioners re-opened the Swift Ditch it ran for one and three-quarter miles along the south-east boundary of Andersey Island and was entered less than a mile downstream of Nuneham Park. Less than a hundred yards along the stream was the lock and about halfway along the length of the stream was an earlier constructed flash-weir. Above and below the weir were pools that could accommodate a number of barges. The Swift Ditch passes under Culham bridge and enters the main stream about three-quarters of a mile below Abingdon bridge. It was visited by Thacker in 1910 when he discovered the old lock without gates and the lower end damned with masonry. He found the walls of the lock 'firm and exact stonework, beautifully laid' and much superior to the construction of certain other locks built at a later date. Another reference to the construction of the lock is in *Oxfordshire* by Robert Plot. He states:

'First, there are placed a great pair of Folding doors, or Flood-gates of Timber across the River, that open against the stream and shut with it, not so as to come even in a straight line, but in an obtuse angle, the better to resist and bear the weight of the water, which by how much the greater it is, by so much the closer are the gates pressed; in each of which Flood-gates there is a sluce to let the water through at pleasure, without opening the gates themselves. Within these there is a large square taken out of the river, built up at each side with Free-stone, big enough to receive the largest barge afloat; and at the other end another pair of Flood-gates, opening and shutting, and having sluces like the former.'

The Oxford Commissioners period of administration did not run smoothly and by 1652 an increasing number of complaints about navigation on the stretch of river made it necessary for the Commissioners to remonstrate with various mill-owners concerning their levying of tolls on passing traffic and making charges for creating a flash of water by opening their weirs. Although the new locks greatly improved navigation, the mill-owners retained considerable control of the levels of the river by means of the weirs adjacent to their mills. It was within their power to determine when a flash of water would be created, and they made a practice when their mills were not grinding of shutting down the mill stream and starving the stretch of water below the lock with the intent of grounding barges. They would then force the bargemaster to buy a flash of water that would enable the barge to be floated off the shallows and brought up to the lock. The author of *Oxfordshire* makes it clear that although about forty-five years had elapsed since the construction of the new locks, '. . . the River Thames is not made so perfectly navigable to Oxford, but that in dry times, barges do sometimes lie aground three weeks, or a month, or more, as we have had experience this last summer.' Some years later, in 1685, there were further adverse comments about the condition of the Oxford-Burcot section of the river and owing to a dry winter, barges were unable to navigate certain stretches. Almost ten years later the situation had not improved and the Oxford Commissioners had to concede that the mill-owners together with certain land-owners had control of the river to such a degree that the Commissioners had subsided from their role as reformers of the river to merely toll collectors. In addition to the Commissioners' difficulties, the owners of flash-weirs were exacting unreasonably high tolls and there was 'alleged ruffianism and obscenities' among the bargemen. These mounting problems resulted in an Act (William III) of 1694 that remained in force for nine years and determined the tolls at locks and flash-weirs. When the statute expired, the owners of the flash-weirs again exacted exorbitant tolls, and money was taken for the use of the towing path with the result that the cost of conveyancing goods by barge also increased. To combat this state of affairs the earlier statute was revived by an Act (George II) of 1730, although by 1739 it was claimed that bargemen were defying the authority of the Commissioners and there were instances of bargemen breaking through locks without paying tolls.

THE LOCKS DURING THE PERIOD OF THE
THAMES NAVIGATION COMMISSIONERS

Following the period the Oxford Commissioners improved part of the river with the construction of the first locks, almost 140 years elapsed before the next improvement to navigation on the river was put into effect. The Thames Navigation Commissioners, who were formed by an Act (George II) of 1751 to control the river between Cricklade and Staines, had at first very few effective powers. Notably, the powers they were given did not allow them to build locks on the river; they could mend existing navigational structures, and issue warnings they could not implement against offenders who misused the river. This unsatisfactory situation changed in 1770 when the Thames Commissioners obtained an important Act (George III) that granted them the additional powers they required. It enabled them to purchase existing towing paths and old flash-weirs as well as build new towing paths and locks. At this time, the bargemasters using the river were frustrated by the numerous shoals and loss of parts of the towing path where it had been washed away, and it was these impediments that caused considerable delay in the passage of barges to and from London. The Thames Commissioners were aware that proposals were afoot to construct canals to by-pass difficult sections of the river, and in particular a proposal by James Brindley was to build a canal between Reading and Monkey Island at Bray, the latter about two river miles below Maidenhead bridge. With their new powers the Thames Commissioners acted quickly to thwart the canal proposal and they engaged upon a major enterprise to build a series of locks between Sonning and Maidenhead, which was the stretch of river the proposed canal would by-pass (Maps 9-10). This was the first series of locks to be built on the river since the period of the Oxford Commissioners and it comprised Sonning, Shiplake, Marsh, Hambleden, Hurley, Temple and Marlow, all built in January 1773, and Boulter's built in December 1772.

In 1771 the Thames Commissioners had engaged a contractor to build the locks using timber and they imposed a time limit of three months for their completion. In the early stages of the work the Commissioners considered the contractor to be dilatory in his duties and although their initial reaction was to discharge him, they thought better of it as most of his plant was already in position. A compromise was reached by arranging for a 'collaborator' to work with the contractor and with this arrangement the work proceeded more quickly, though not within the stipulated period of

three months. Following the building of this first series of locks, the river below Oxford and as far as Maidenhead was fairly navigable with the locks able to take barges up to 140 tons laden weight. But the quality of construction of the locks was not good and many of the flash-weirs on the river were kept operational by their proprietors with a view to their possible future use, while at the same time a provision of the Act required the Commissioners to pay the proprietors the tolls they would have collected had the barges continued to pass through their weirs instead of the new locks.

In 1774, shortly after the locks were opened, small wooden houses were built for the lock-keeper at Sonning, Hambleden and Boulter's. Later, in 1777, the wooden construction at Hambleden was replaced by a small brick house and in the same year a similar house was built at Temple; later still, houses were built at Marsh (1813) and Marlow (1815). But the cheap construction of the locks was beginning to show and the Commissioners' committee of enquiry, held in 1780, found Sonning 'going into general decay', Marsh 'decaying fast', Hurley in a 'very shattered condition', Marlow in a 'very shattered and decaying state' and Boulter's in as 'bad a state as Marlow, if not worse'. This state of affairs eventually led to a general programme of repairs to the locks and rebuilding in some instances; but again the Commissioners chose timber in preference to stone on the grounds of cost; though no doubt the appointment by the Commissioners of John Treacher, a builder and contractor, as general surveyor of the river and Robert Mylne as a consulting engineer, had an effect upon the quality of the work. Sonning, Shiplake, Marsh and Hurley locks were initially built of fir and the former three subsequently rebuilt of oak; Sonning at various times, Shiplake in 1787 and Marsh in 1788. Hambleden lock was dilapidated by 1814 and the upper gates could be opened only with tackle owing to the leaking lower gates. The old flash-weir at Hurley was brought back into use in 1785 when Hurley lock was rebuilt in brick, and in 1788 the brick abutments were replaced with stone. Marlow lock was rebuilt in 1825 and Boulter's lock was built on a new site in 1829. The locks that had initially been built in oak were not rebuilt until much later during the jurisdiction of the Thames Conservancy.

The initial improvements to the river afforded by the first series of locks was not maintained and when the Oxford canal was opened in 1790, the passage of the additional traffic between Oxford and London did not flow as freely as it might have done. The problems with the first series of locks were such that when the Grand Junction canal was completed in 1800, it diverted much of the traffic from Birmingham to London, which previously had taken the Oxford canal and Thames route.

*

With the completion of the first series of locks between Sonning and Maidenhead (Boulter's) there existed two sections of the river served by locks; the aforementioned and the pioneering venture of almost 140 years earlier between Oxford and Burcot. Following the completion of the first series of locks in 1772/73, five years elapsed before the Thames Navigation Commissioners started work on what would be the second series of locks, which would join with the first series and create a continuous series of locks between Oxford and Maidenhead. The second series started at Dorchester, just one-and-a-half river miles downstream of Burcot, and finished at Reading, almost three river miles above Sonning. The series comprises Day's, Benson, Cleeve, Goring, Whitchurch, Mapledurham and Caversham (Maps 6-8). But unlike the procedure adopted for the Sonning to Maidenhead section of the river, when all the locks were constructed in a short period of time, the second series was worked over a period of twelve years. In spite of the Thames Commissioners being short of funds, the first lock was built adjacent to the old flash-weir that served Mapledurham mill. The lock was built of fir in 1778 and opened to traffic in the same year it was built.[1] As decided by the centre line of the river, which is the county boundary between Berkshire and Oxfordshire, the lock was in the parish of Purley and it was intended that it should be called Purley lock. Local opinion prevailed however and the name of the lock was changed to Mapledurham in order to retain continuity of name between the lock, weir and mill. A lock-keeper's house was not provided until about 1816, although a 'watch box' constructed in the style of a sentry box was provided for the keeper in 1798. The second lock was built (again of fir) at Caversham and it was opened to traffic in 1778, though owing to difficulties the Commissioners encountered purchasing land, a lock-house was not built until 1819.

Nine years elapsed between the construction of Caversham lock and the three locks upstream of Mapledurham: Whitchurch, Goring and Cleeve. Whitchurch lock was first contemplated by the Commissioners in 1785 and was built in 1787. A number of possible channels were considered and one scheme was to create a cut through the site of the Swan Inn, which would involve purchasing the inn for a sum of £600. But common sense prevailed and a more accessible route was taken through an island adjacent to Whitchurch mill and into the upper millstream. The lock was built with

1. F S Thacker states the year of construction and opening to traffic as 1777.

open sides and oak abutments, though Robert Mylne complained fifteen years later that 'this [Whitchurch] Pound-lock is of Oak and very badly and ignorantly framed.' The matter of providing a lock-house did not arise until 1829, forty-two years after the lock had been built. The house was sited on the lock-island even though the Commissioners were aware the island was liable to flooding, and their only acknowledgement of this hazard was that the house should 'be raised a little.'

Goring and Cleeve locks were built in the same year as Whitchurch lock, though the style of construction was of oak with closed sides. The two locks are close together with Cleeve about half a mile upstream of Goring. In their early history they were frequently in the charge of the same keeper, as each lock was adjacent to a mill and the two mills were under single ownership. Consequently, the miller was concerned with keeping control of the water levels on this part of the river and his actions led to problems passing barges through the locks. This was not an isolated instance when the Commissioners' best interests were not served by their engaging a lock-keeper whose duties were manipulated by the local miller, and it was not until 1869 that the Conservators of the River Thames, who succeeded the Thames Commissioners, recommended separate management of the two locks. Although a lock-house at Goring was suggested 'in order that the keeper may have no excuse for being absent from the lock' during the period of the separate management arrangement, the proposed lock-house was not built until 1879. The remaining two locks of the second series are Benson and Day's. Benson lock was built in 1788 and Day's lock in 1789, and both locks were built of oak with open sides.

*

The work carried out by the Thames Navigation Commissioners up to 1789, the time of completion of the second series of locks, had made a great improvement to navigation between Oxford and Maidenhead. But there was a further major improvement that had become necessary owing to the joining of the newly constructed Thames and Severn canal with the Thames at Inglesham. Before the first laden canal boat reached St John's bridge at Lechlade in November 1789, the Thames and Severn Canal Company had pressed the Thames Commissioners to carry out improvements to the river below Lechlade. The Commissioners engaged William Jessop in early 1787 to survey the river between Lechlade and Oxford and the authority to carry out the necessary improvements came in the form of the Thames Navigation Improvement Act (George III) of 1788, an Act that enabled the Commissioners to improve the river within their

jurisdiction below Cricklade and particularly the stretch between Lechlade and Oxford. The Thames and Severn Canal Company were well aware that the commercial success of the canal depended on the passage of barge traffic between Inglesham and Oxford and finally London. And at the same time the additional barge traffic would create extra revenue for the Commissioners. By April 1789 the canal had been cut to within a few miles of Inglesham, but the Commissioners had not begun the improvements to the river below Lechlade. The proprietors of the Thames and Severn Canal Company had already examined ways of improving navigation between Inglesham and Buscot where the state of the river was at its worst; but it was beyond the proprietors' means to extend their canal to Buscot in order to by-pass this bad section of the river, and they tried to persuade the Commissioners to make their own cut as opposed to building a lock at Lechlade and Buscot. Their proposal was frustrated by a difference of opinion between two of the most prominent commissioners concerned with navigation on the upper river; Edward Loveden was in favour of the cut proposed by the canal proprietors, but William Vanderstegen was not, and nothing was achieved at the joint meetings of the canal proprietors' committee and the Commissioners. Very shortly after this impasse the canal proprietors conveyed to the Commissioners that they 'expected and required' the river to be put into a navigable state. Without further delay the Commissioners again engaged William Jessop to survey the river between Lechlade and Day's lock at Dorchester with a view to improving navigation by increasing the depth of water to at least three feet six inches in the dry season. Jessop henceforth went about his survey in July and August 1789 and recorded his findings in the form of two reports. His first report dated 4 August concerned the state of the river between Lechlade and Oxford.

Jessop pointed out to the Commissioners that it was necessary with any scheme of improvement to a waterway to have local knowledge as well as the circumstances under which changes to the waterway occurred. With the limited time at his disposal he was unable to collect as much information as he would have wished, but his observations and the information he gathered from others allowed him to present the Commissioners with the most material objects for their attention. He made no small issue of bringing to the Commissioners' attention that the depth of water gained by the natural stream of a river of a given width depended upon two factors: the quantity of water and declivity or fall of the river. In an instance of sufficient quantity of water, but insufficient depth owing to too greater width, then the depth of water could be increased by reducing the width of the river without altering the declivity. Nevertheless, this was not the complete answer and the alternative step would be to increase the depth by

reducing the declivity by means of weirs. Unfortunately, the management of the river was not solely within the jurisdiction of the Commissioners owing to a number of privately owned mills and fisheries and the partial control of the water exercised by their owners. With this restriction in mind, Jessop described the improvements to the navigation he considered necessary.

The state of the river at that time resulted in the grounding of laden barges owing to a lack of adequate depth of water, and in addition there was a need for a convenient towing path for the barge horses. Some improvement could be achieved by removing the many shoals and continuing the practice of creating flashes in order to raise water levels temporarily over stretches of the river, but Jessop preferred the building of locks on the understanding that their effect would be beneficial throughout the length of the river and not simply their immediate location. He proposed that the locks should be sited where the greatest obstructions presented themselves to barge traffic. And in the case of the towing path, he suggested raising the level of the path in low and wet places and making bridges and cutting down trees to increase the length of the path on one side of the river; in this way the need to ferry the barge horses from one side of the river to the other would be reduced.

The highest lock Jessop proposed was just above St John's bridge at Lechlade. By building the lock across a bend in the river and adding a new arch to the bridge to take the lock-cut on the Berkshire side, the passage into the river below the bridge would be direct. In addition to the lock a weir above the bridge would be necessary. The next lock downstream would be at Buscot with a short cut on the north side of the river; following Buscot he proposed a third lock at Old Nan's weir with a cut of 400 yards on the south side of the river that would by-pass a very crooked and obstructed section of the stream. The next and fourth lock would be sited at Pinkhill weir,[1] by-passing a large bend in the river by means of a suitable cut which would avoid some very bad shoals. The fifth lock would be near Godstow bridge at the tail of a cut about 400 yards in length, made above the bridge and on the west side of the river somewhere near Woodward's Hole. This latter lock would considerably ease the fall of the river from King's weir to Godstow. The sixth and final lock at Oxford had been started by the Commissioners before they received Jessop's report, and Jessop took the liberty of pointing out the site they had chosen as unsuitable. He then gave reasons for siting the lock a further 200 yards downstream close to Osney mill: his main reason for this change was to reduce the length of the

1. Pinkhill weir was about three-quarters of a mile downstream of Skinner's weir, and at the time was owned by Lord Harcourt.

tail-cut the former site required, as experience had shown that the passage of water through a long tail-cut was insufficiently vigorous to remove the sand or gravel bar that accumulates where the lock cut enters the river; a common occurance in times of flood.

To conclude his first report, Jessop proposed that the locks should be built of stone as the material was available at small expense by means of the 'Gloucestershire' canal,[1] he also specified Aberthaw lime as the best available for the works; the weirs were to be made of oak with elm for those parts underwater; the bridges for the towing path were also to be of oak.

Jessop's second report of 7 August 1789 was concerned with the river from Oxford to Day's lock at Dorchester. But the time available to him was limited and he was in a position to make only general observations. His main cause for complaint was the state of the river at Abingdon, where he found almost continual shoals below the lock at the head of the Swift Ditch and as far as the junction with the main river. He was aware that the Commissioners had been considering the future of the Swift Ditch as a navigational channel, as well as the construction of a lock at Abingdon to enable barge traffic to pass close to the town. But he pointed out that this would require much work to be done in removing obstructions downstream of the proposed site of the lock. He made further recommendations and in particular he commented upon the new lock at Dorchester (Day's lock) and the long reach upstream to Abingdon. As there existed a number of extensive shoals along the reach, he proposed dividing it with a flash-weir thereby increasing the depth of water above the weir and by means of flashing assist barges over the shoals below the weir. If this work was undertaken he suggested that the old lock at Sutton, just two river miles downstream of Abingdon bridge, should remain, subject to raising the underside of an old building above the lock basin to make the passage of barges beneath it more possible at times of high water.

William Jessop's reports were considered and approved at a general meeting of the Commissioners held at Faringdon on 20 August 1789, and the locks they built between Lechlade and Oxford formed the third series of locks on the river. The six locks are St John's (Lechlade), Buscot, Rushy, Pinkhill, Godstow, Osney (Oxford), and they were built in 1790/91 (Maps 1-3). Unlike the earlier series of locks built by the Commissioners, the locks between Lechlade and Oxford were built of stone in accordance with Jessop's recommendation. Of the two highest locks, St John's and Buscot,

1. Jessop was referring to the newly opened Thames and Severn canal.

the early history of Buscot lock is the most interesting as the river at this point flowed through Buscot Park, the estate belonging to Edward Loveden whose business interests prompted him to play an active part in the improvements to the upper Thames navigation. Not only did Loveden own the weir at Buscot as well as a wharf downstream, which enabled barges to deliver salt, coal and other cargoes to Buscot Park, but in 1791 he had a cottage built to accomodate a lock-keeper. What might be described as a generous undertaking had in fact a double purpose, and it is best described with an extract from *The General View of the Agriculture of Berkshire* published in 1809:

> '. . . must not omit to mention Mr. Loveden's plan of a "fish-house which cannot be robbed." It is built on a small peninsula, surrounded on three sides by a branch from the Thames; and has iron grates to the east and west, to allow the water a free passage. Within the limits of the building, whose exterior appearance is that of a neat cottage, are three stews, about eight feet deep from the ground floor, and standing on an average three in water, which communicate with each other by holes bored through the wooden partitions. These stews are covered with trap doors, which when locked, even the person who inhabits the cottage connected with them, could not open and get at the fish, without the certainty of detection. Where noblemen and gentlemen of fortune are desirous of having a regular supply of fish for their tables, and at the same time of providing a residence for a dependent [in this instance the lock-keeper], this kind of fish-house may be beneficially erected.'

The situation at St John's lock was different to that at Buscot for although a lock-keeper was appointed, a lock-keeper's house was not built until 1830. At the time the house was built the keeper appointed by the Commissioners declined to reside in it as he had accommodation nearby. This was a matter upon which the Commissioners stood firm; the keeper was given six months to take up residence in the lock-house provided, or resign his appointment. There were however problems immediately following the construction of the lock. In 1792 the Commissioners were made aware that tolls were being evaded by bargemen who took little notice of the authority of the lock-keeper. And in 1793 it was said that no barge could pass along the stretch of river downstream of St John's lock unless a flash was created at St John's bridge and allowed to run for three hours. As each year passed by the bargemen continued to evade paying tolls and in 1798 a barge from the Thames and Severn canal damaged St John's lock. As the bargmaster was already in arrears over payment of tolls, the Commissioners took the unusual step to prosecute unless he would advertise his regret over the incident in the Oxford and Reading newspapers, which presumably he did.

Of the next two locks downstream, Rushy and Pinkhill, it is Pinkhill that

Robert Mylne in 1793 described as 'of no Kind of Use in itself to the Navigation on Account of the old Weir of Timber in the Bed of the River being totally rotten and tumbled into the River, and seemingly deserted.' What Mylne no doubt meant was that the inability of the weir to maintain a useful level of water above the lock, made the operation of the lock almost impossible.

The last two locks downstream were not without their problems. Godstow lock, situated a mile downstream of King's weir, raised the water level between the weir and lock sufficient to destroy the fordway into Pixey Mead, thereby depriving farmers of easy access to Port Meadow and turning fine pastureland at Yarnton into 'coarse, worthless grass.' During the excavation of Godstow lock, which was close to the ruins of a nunnery, coffins of the prioresses were 'disturbed and displaced', though it remains unclear whether they were removed altogether or re-buried at the site of the lock cut. Osney lock is sited a little more than two miles below Godstow lock and a mile below Medley weir, and it is on this section of river between the weir and Osney lock that the newly opened (1790) Oxford canal enters the river. The lock was initially proposed in 1787 in anticipation of the opening of the Oxford canal as it would provide stability to the level of water below Medley weir, which operated as a flash-weir. Later, in 1793, there was a proposal for a small lock to be built adjacent to the weir to benefit the passage of pleasure craft, but the proposal was not implemented, although on a plan of 1798 a single pair of gates is shown and they were used as a flash-lock until the middle of the nineteenth century. In 1883 the Conservators of the River Thames, who succeeded the Thames Navigation Commissioners, proposed to remove Medley weir as it was claimed that it constituted a 'great impediment' and contributed to the 'wretched state of the River above it.' But the necessary funding was unavailable and it was not until the late nineteen-twenties that the work was carried out.

In April 1791 the Commissioners wanted William Jessop to survey the work that had been done in accordance with the proposals he had made in his reports, but Jessop was busy and the Commissioners turned to Robert Mylne for an opinion of the river and his suggestions for further improvements. Mylne's first report was concerned with the state of the river between Lechlade and Abingdon. He started his survey on 26 April and his initial comment was that the state of the river was 'excellent', though there was room for improvement. He was anxious to point out to the Commissioners that the river was no longer concerned with its own commerce alone; there were now two canals (Thames and Severn 1789 and

MAPS OF THE RIVER

The maps show the river between Inglesham and Teddington. The position of each lock and weir is based upon two published maps of the river; one in the late nineteenth century and the other in the mid-twentieth century.

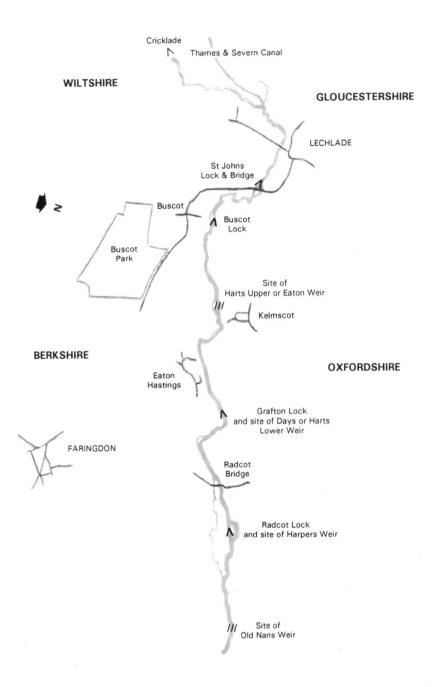

MAP 1. The third series of locks built in 1790/91 by the Thames Navigation Commissioners. The series comprises St John's, Buscot, Rushy, Pinkhill, Godstow and Osney. Continued on Map 2. The Thames Conservancy built Grafton in 1896 and Radcot in 1892

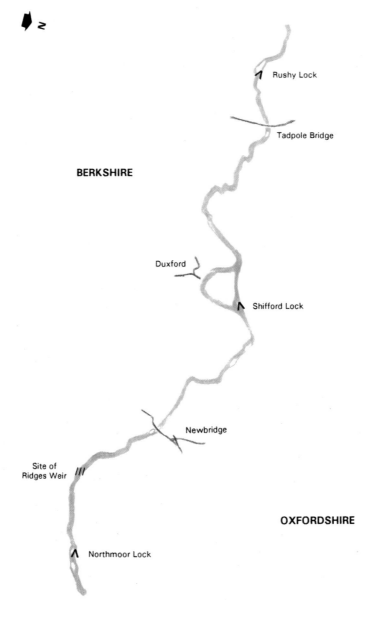

N

Rushy Lock

Tadpole Bridge

BERKSHIRE

Duxford

Shifford Lock

Newbridge

Site of
Ridges Weir

OXFORDSHIRE

Northmoor Lock

MAP 2. The Thames Conservancy built Shifford in 1898 and Northmoor in 1895. Continued on Map 3.

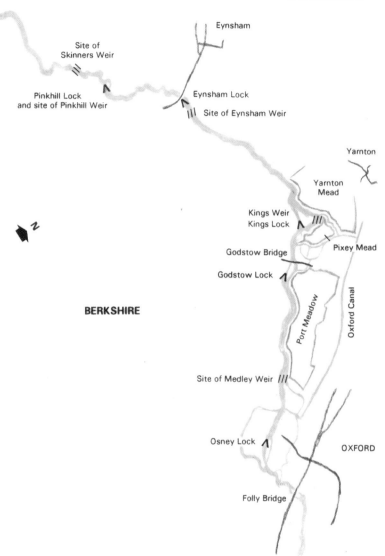

OXFORDSHIRE

Eynsham

Site of
Skinners Weir

Pinkhill Lock
and site of Pinkhill Weir

Eynsham Lock

Site of Eynsham Weir

Yarnton

Yarnton
Mead

N

Kings Weir
Kings Lock

Pixey Mead

Godstow Bridge

BERKSHIRE

Godstow Lock

Port Meadow

Oxford Canal

Site of Medley Weir

Osney Lock

OXFORD

Folly Bridge

MAP 3. The Thames Conservancy built Eynsham and King's in 1927/28.

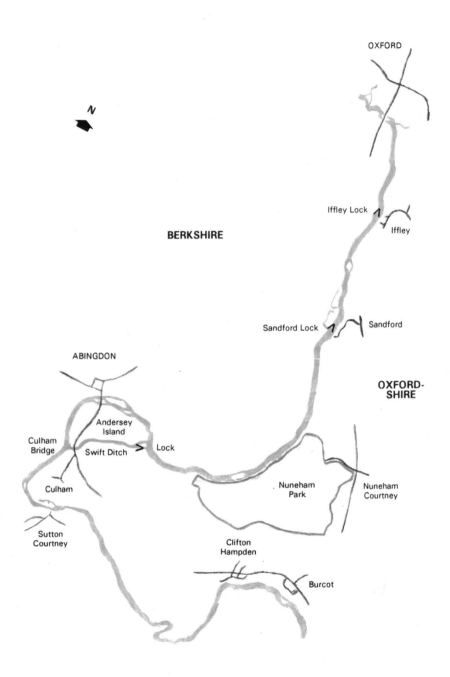

OXFORD

N

Iffley Lock

Iffley

BERKSHIRE

Sandford Lock

Sandford

ABINGDON

OXFORD-
SHIRE

Andersey
Island

Culham
Bridge

Swift Ditch

Lock

Culham

Nuneham
Park

Nuneham
Courtney

Sutton
Courtney

Clifton
Hampden

Burcot

MAP 4. The first locks built by the Oxford Commissioners: Iffley and Sandford c.1630 and the Swift Ditch lock c.1635.

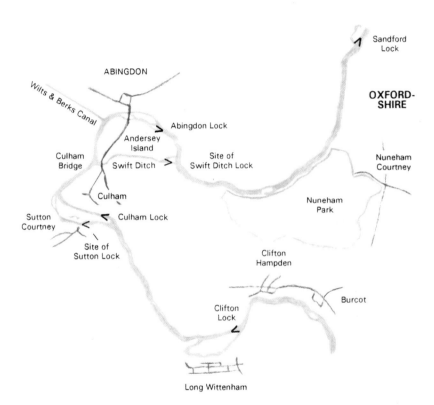

MAP 5. The first group of the nine locks built between 1790 and 1845 by the Thames Navigation Commissioners: Abingdon 1790, Culham 1810 and Clifton 1822. The Swift Ditch lock was abandoned when Abingdon lock was built and the privately owned Sutton lock was removed in 1845.

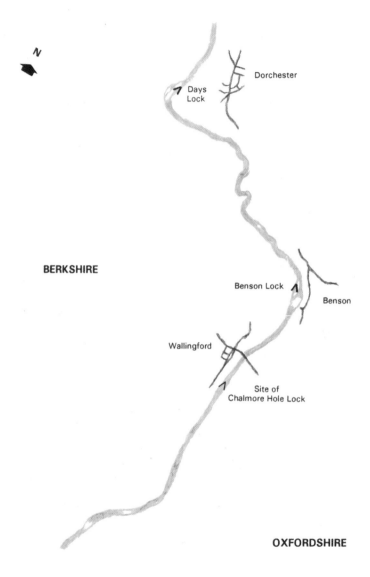

N

Dorchester

Days
Lock

BERKSHIRE

Benson Lock

Benson

Wallingford

Site of
Chalmore Hole Lock

OXFORDSHIRE

MAP 6. The second series of locks built between 1778 and 1789 by the Thames Navigation Commissioners. The series comprises Day's, Benson, Cleeve, Goring, Whitchurch, Mapledurham and Caversham. Continued on Map 7. Day's and Benson were built in 1789 and 1788 respectively. Chalmore Hole was built later in 1838.

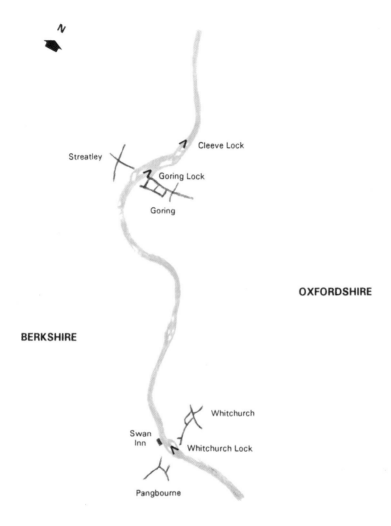

N

Cleeve Lock

Streatley

Goring Lock

Goring

OXFORDSHIRE

BERKSHIRE

Whitchurch

Swan
Inn

Whitchurch Lock

Pangbourne

MAP 7. Cleeve, Goring and Whitchurch were built in 1787. Continued on Map 8.

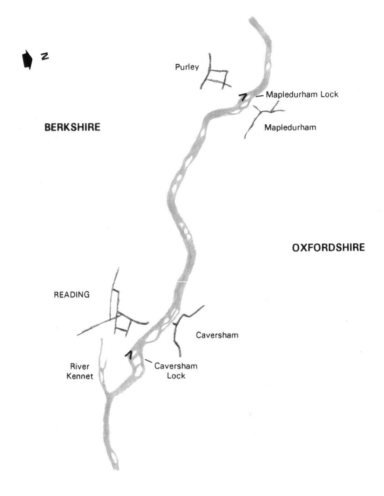

MAP 8. Mapledurham and Caversham were built in 1778.

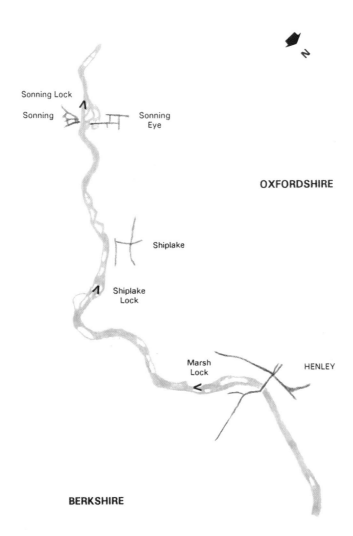

N

Sonning Lock

Sonning Sonning
 Eye

OXFORDSHIRE

Shiplake

Shiplake
Lock

Marsh
Lock HENLEY

BERKSHIRE

MAP 9. The first series of locks built in 1772/73 by the Thames Navigation Commissioners. The series comprises Sonning, Shiplake, Marsh, Hambleden, Hurley, Temple, Marlow and Boulter's. Continued on Map 10.

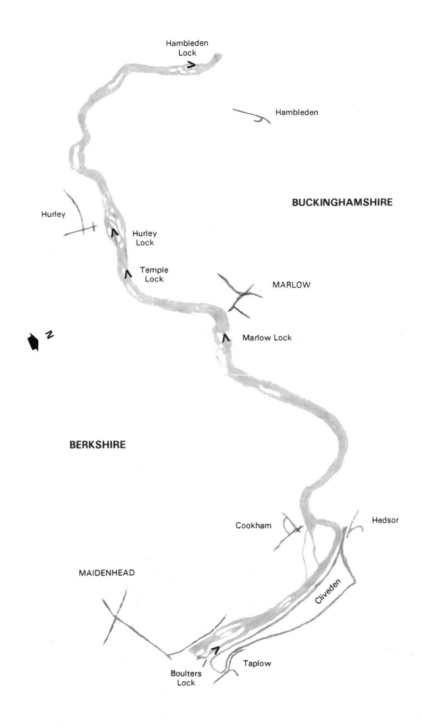

Hambleden
Lock

Hambleden

BUCKINGHAMSHIRE

Hurley

Hurley
Lock

Temple
Lock

MARLOW

Marlow Lock

N

BERKSHIRE

Cookham

Hedsor

MAIDENHEAD

Cliveden

Taplow

Boulters
Lock

MAP 10. Boulter's, built in 1772, was sited on the Buckinghamshire side of the river close to Taplow mill.

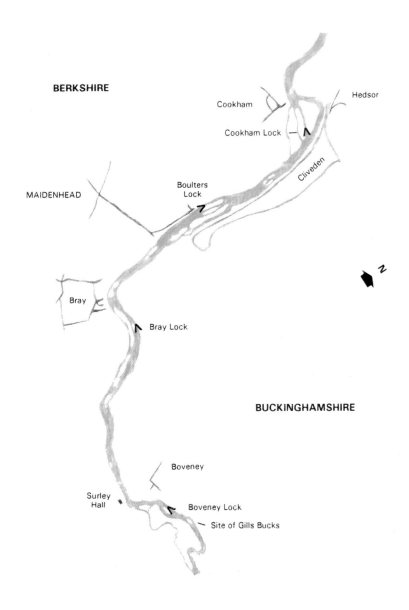

BERKSHIRE

Cookham

Hedsor

Cookham Lock

Cliveden

MAIDENHEAD

Boulters
Lock

N

Bray

Bray Lock

BUCKINGHAMSHIRE

Boveney

Surley
Hall

Boveney Lock

Site of Gills Bucks

MAP 11. The second group of the nine locks built between 1790 and 1845 by the
Thames Navigation Commissioners. Cookham 1830, Bray 1845, Boveney 1838.
Continued on Map 12. During this period, Boulter's was built on a new site in 1829
on the Berkshire side of the river and the original lock of 1772 was abandoned.

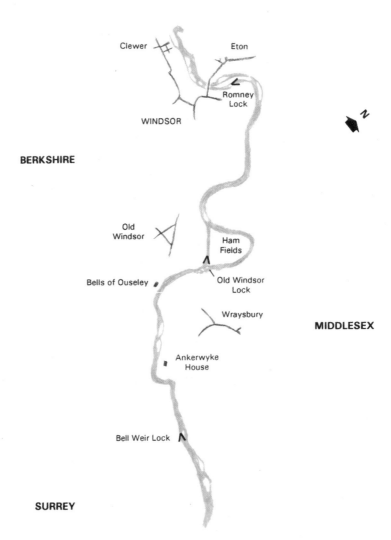

Clewer

Eton

Romney
Lock

WINDSOR

BERKSHIRE

Old
Windsor

Ham
Fields

Bells of Ouseley

Old Windsor
Lock

Wraysbury

MIDDLESEX

Ankerwyke
House

Bell Weir Lock

SURREY

MAP 12. Romney 1798, Old Windsor 1822 and Bell Weir 1819.

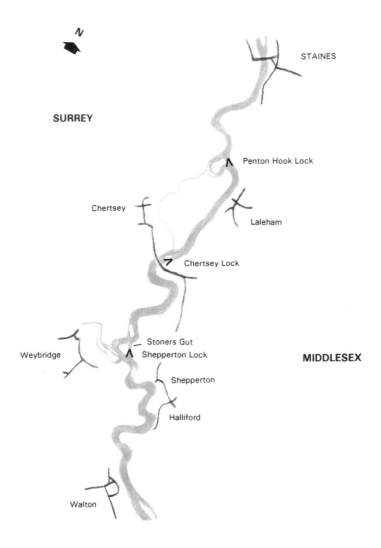

N

STAINES

SURREY

Penton Hook Lock

Chertsey

Laleham

Chertsey Lock

Stoners Gut

Weybridge

Shepperton Lock

MIDDLESEX

Shepperton

Halliford

Walton

MAP 13. The fourth series of locks built between 1811 and 1815 by the City of London Corporation. Penton Hook 1815, Chertsey and Shepperton 1813. Continued on Map 14.

MAP 14. Sunbury 1812, Molesey 1815 and Teddington 1811.

Oxford 1790) adding traffic to the river. It was a priority therefore to establish a towing path the whole length of this section of the river, and this required completing the work Jessop had proposed. He argued that the site chosen by Jessop for each of the locks may have been selected differently to make the navigation more perfect, but what had been done was irreversible and must therefore be accepted. He also recommended most strongly that in instances where a privately owned weir adjoins a lock (an essential arrangement to establish the depth of water above the lock), the weir should be purchased giving the Commissioners sole right of management for the purpose of maintenance and setting water levels. Most importantly he saw the necessity for the Commissioners to have all the weirs under their control, and not only those adjoining locks. He had in mind weirs belonging to mills and fisheries where in some instances owners were neglectful of maintenance or simply had insufficient funds to carry out necessary repairs. There was no doubt in Mylne's mind that improvements to the river would be ineffective unless the weirs on the river were worked in a manner that would allow the proper operation of the locks in times of short water or flood. He also recommended that each lock should have a keeper who would operate the lock, receive tolls and manage the weir adjoining the lock.

After establishing what Mylne described as the 'general principles' of further improvement, he went on to make specific recommendations. These amounted to building additional locks between Lechlade and Abingdon, bringing the total number of locks on this stretch of the river to sixteen. The Commissioners had already built five locks between Lechlade and Oxford and were building one further lock, but Mylne's report required another seven locks, which he claimed would make redundant a number of existing flash-weirs and maintain an average depth of four feet of water in the reach above each lock.[1] With this arrangement he expected that in times of flood there would be a general declivity of the waters throughout the stretch of river, but as the flood waters subsided the river would assume the appearance of a navigable canal. Nevertheless, in times of short water there would still be difficulties for barge traffic owing partly to the many shoals in

1. The seven locks Mylne proposed between Lechlade and Oxford were: (i) a site between Hart's upper weir and Day's weir; (ii) the site of Buck's or Clark's weir, which was less than a mile below Radcot bridge (seventy-five years later records listed the weir as Harper's); (iii) the site of the weir at Ten Foot bridge, about three miles below Rushy lock; (iv) the site of Shifford weir, which probably was adjacent to Shifford church; (v) a site between 'Langley's weir' (this was most likely Limbre's weir, about half a mile above Newbridge) and 'Hart's ferry' or Ridge's weir, one-and-a-quarter miles below Newbridge; (vi) the site of Ark weir, three miles below Newbridge; (vii) a site below Folly bridge, Oxford.

the river, and these would need to be removed.

It is not unlikely that the Commissioners were dismayed by Mylne's first survey, and on examining his report and comparing it with the two earlier reports by William Jessop, the Commissioners saw only too clearly that Jessop and Mylne differed in their opinion as how best the stretch of river could be improved. Hence, the Commissioners resolved at a general meeting held on 31 May 1791 not to adopt the recommendations for further improvements to the river until a select committee of commissioners examined the sites indicated in the report.

The select committee was formed of five commissioners with Robert Mylne, Zachary Allnutt as secretary, the district surveyors for that part of the river and in attendance some bargemasters who were well aquainted with difficult sections of the river. They boarded the Commissioners' shallop at Lechlade on 18 July and proceeded first to Inglesham where the Thames and Severn canal entered the river, and thence downstream to Whitchurch where they arrived on 22 July; the following day they completed their report.

During their progress downstream the committee satisfied themselves that Buscot weir was old and rotten as Mylne had stated in his report, and there were many more such instances as they quickly found out. Owing to its derelict state, the only way of getting past Old Nan's weir was to lift their shallop over the rotting timbers. They now saw the necessity for giving notice to owners of weirs to carry out repairs in order to maintain a constant head of water to meet the needs of the locks. They also saw the wisdom in Mylne's recommendation that the Commissioners should purchase as many weirs as possible. The committee also observed the loss of water from the main stream as it passed into back streams and they recommended gauge weirs to be built to stop the loss of water. The state of Godstow lock was a matter of concern as the walls were not of a favourable appearance owing to irregularity in the courses of stone used in the construction. Osney lock was in a worse state as the wing walls at the tail gates had given way, and there were a number of other defects giving a clear indication that the contractor had not made a sound job of constructing the lock which, like Godstow, was barely a year old.

When the committee reached Oxford they paused in order to make an important decision based on the state of trade on the river above and below the city. They were seriously concerned whether the proposals made by Mylne, which included the construction of more locks, could with propriety be adopted in addition to the work already carried out in accordance with Jessop's recommendations to improve the river between the junction of the canal at Inglesham and the City of Oxford. The committee felt that it might

be more prudent to confine the Commissioners' limited funds to completing Pinkhill lock and carrying out the other works they had so far indicated in their report; principally, to prevent the diversion of water from the navigational stream, to increase the depth of the river by removing shoals, and to complete the towing path for the barge horses. These works were of course part of Mylne's overall scheme, together with his recommendation to bring pressure to bear on owners of weirs who were dilatory in matters of maintenance and repair. The committee therefore were of the opinion that keeping a good depth of water between the existing locks would render the practice of creating flashes of water unnecessary, and the rest of Mylne's scheme could be implemented at some later date without 'Impropriety or Inconvenience'.

Taking the committee's report into account the Commissioners were faced with what was probably their most important decision concerning the future of the Thames as a navigational highway, not only for the existing trade, but for the trade that was being created by the Thames and Severn canal and the Oxford canal. The Commissioners accepted their committee's views and decided not to proceed with the most important part of Mylne's scheme, principally because of the uncertainty they felt about the expected volume of barge traffic the canals would provide. The decision was unfortunate and it damaged the prospect of the upper river becoming a commercially viable waterway.

It was perhaps unfortunate that in 1793 Mylne made certain scathing comments about the workability of the Thames and Severn canal. Subsequently, a shareholder of the Thames and Severn Canal Company criticised the Commissioners for failing to make further improvements to the river between Lechlade and Oxford, and the matter was taken before a committee of the House of Commons that year. The committee found that the Commissioners were negligent in their endeavour to improve the river, even though the problems were caused by obstructions in the form of flash-weirs and the fact that the Commissioners found considerable difficulty persuading the owners to carry out repairs to the structures, of which many were sited between the locks built by the Commissioners. The committee was aware of this and acknowledged that the 'grand cause of Delay in its Navigation cannot be removed until after the old [flash] Locks and Weirs, etc., are purchased and placed under the absolute control of the Commissioners and the Practice of Flashing abandoned.' Some years later, in 1811, the Commissioners commented upon the failure of the Thames and Severn canal to create the traffic the Commissioners reasonably expected. But the comment did more harm than they imagined, and the result was

that the Thames and Severn Canal Company joined with the Wiltshire and Berkshire canal to promote the North Wiltshire canal and so enable canal traffic to avoid the upper Thames. Although revenue from canal traffic was greatly reduced it was not until the last days of the Thames and Severn canal in the eighteen-nineties that the Conservators of the River Thames, being well aware of Mylne's reports of 100 years earlier, built more locks between Lechlade and Oxford to improve navigation on that section of the river.

At the time Robert Mylne was making his first survey and report for the Thames Navigation Commissioners there was a flash-weir sited under Folly bridge at Oxford, which he reported as being in bad order. As a result of damage to the narrow navigation arch of the bridge at about that time, repairs were undertaken, but by 1803 the arch was impassable and further repairs were necessary. An Act (George III) of 1815 was eventually obtained to rebuild the bridge and the works were completed in 1827. At the time of the Act of 1815 the flash-weir under the bridge was removed and re-sited about 200 yards upstream. In 1820 an 'extra pen lock' was proposed and according to Thacker it was probably completed the following year 'on the right bank behind Salter's rafts' with a lock-house at road level. It is believed that the lower end of the lock had ordinary gates but the upper end was fitted with sluices so that at times of high water the lock was left open. Even though an order was issued for the removal of the lock in 1829, nothing was done, and in 1867 new gates were needed. By 1884 the lock was in a bad condition and the gates were removed establishing a free passage through the site of the lock.

The original locks pioneered by the Oxford Commissioners at Iffley, Sandford and the Swift Ditch were eventually purchased with other works by the Thames Navigation Commissioners in 1790. In his first report, Robert Mylne made little comment regarding the locks. He found Iffley lock with insufficient depth of water above the head gates for it to operate properly and he pointed out that there was no lock-keeper present. His principal recommendation for the future of the lock was that it should be lengthened. And as for Sandford lock he found the upper gates quite rotten and again he recommended that the lock should be lengthened. This led to the first major work at Iffley lock by the Thames Commissioners in 1793, and comprised rebuilding and lengthening the lock to 120 feet. Two years later a lock-keeper was appointed, although it was not until 1810 that a lock-house was built. In 1802 the lock was repaired and enlarged and in 1806 it was again lengthened, making it necessary to close the lock for three weeks, during which period merchandise had to be carried from one

barge to another above and below the lock.

When Iffley was lengthened in 1793 the same work should have been carried out to Sandford; but it did not come about, even though a report of 1794 tells of the lock being in a 'very dangerous and precarious situation'. However, re-building did take place the following year and much later, in 1836, a new lock was built alongside the old structure and this was followed by a lock-house in 1839.

In Robert Mylne's second report (10 August 1791) to the Thames Navigation Commisioners, he commented on the state of the river between Abingdon and Whitchurch, which included Abingdon lock and five of the second series of locks (Day's to Whitchurch) built by the Thames Commissioners during 1787-89. Mylne's comment on Abingdon lock was not complementary as it had been built only a year when he found it in a state of reconstruction owing to defective side walls. The rebuilding work, he said, is 'tolerable, but not so perfect a Manner as I could have wished'. More out of curiosity than duty, Mylne went on to Mapledurham lock, built in 1778, and found it 'quite ruinous and decayed.' It was improperly built Mylne claimed and in the meantime had been patched with different sorts of timber. Concluding his second report he was of the opinion that the greatest obstacles to good navigation lay with the millers and their manipulation of the levels of water above and below locks close to their mills. They acted in a nefarious manner, Mylne claimed, and it was only for immediate gain as opposed to a long term advantage.

*

The third series of locks, completed by the Thames Commissioners in 1791, was followed by a further eight locks built over the period 1798 to 1845. These cannot be classified as a series, but they do form two distinct groups. The first group includes Abingdon, which had been built in 1790, Culham and Clifton (Map 5); and the second group includes Cookham, Bray, Boveney, Romney, Old Windsor and Bell Weir (Maps 11-12). During the construction of these locks an additional lock was built at Chalmore Hole, about half a mile downstream of Wallingford bridge where the towing path changed from the Berkshire to the Oxfordshire side of the river (Map 6). The suggestion for a lock at this site was made at a parliamentary enquiry in 1793 and when the lock was finally built in 1838 it was described as a 'summer or low-water lock and weir'. The purpose of the lock and weir was to save the grounding of barges during low-water conditions along the stretch of river below Wallingford bridge. The lock was in the form of

'a weir and two pairs of pound gates' with a fall between the two water levels of seventeen to twenty inches. During high-water conditions the upper and lower gates were left open to provide an uninterrupted passage for traffic and no tolls were taken. The lock survived into the late nineteenth century when it was removed in its entirety.

The first group of locks was built to improve navigation on the river between Sandford lock and Burcot. In 1788 there had been a move afoot to reinstate a navigable channel through Abingdon as there had once been before the Oxford Commissioners re-opened the Swift Ditch in 1624. An examination of an alternative scheme that would enable barges to avoid the shoals in the Swift Ditch about Culham bridge was judged impracticable and a year later estimates were obtained to make good the navigation from the Abbey Mill weir at Abingdon by using the stream flowing under Abingdon bridge down to the region of Culham bridge. This latter course of action brought about the building in stone of Abingdon lock in 1790.

Some years later the Wiltshire and Berkshire canal was built and entered the Thames a short distance below Abingdon bridge. The canal was a narrow one and at first it was not intended as a through waterway between Bristol and London but as a means of transporting coal to agricultural areas of the Vale of White Horse. Nevertheless there would be some barge traffic passing through to London and the Commissioners saw the need to improve the river below Abingdon. A lock at Culham had been proposed in 1803 and again in 1806, and with the intention in 1809 to operate fly-boats carrying express goods between Bristol and London by way of Abingdon, a lock became increasingly necessary. The lock was built of stone in 1810 using an existing stream on the Oxfordshire side of the river, thereby making it the main navigation channel and at the same time by-passing the privately owned Sutton lock. The lock at Sutton Courtney dates back almost to the time the first locks were built on the river by the Oxford Commissioners. It certainly existed in the mid 17th century and was a most unusual structure comprising a large lock basin over part of which there was a mill and granary. The upper gates of the lock were beneath the floor of the mill and the lower gates in a narrow channel at the end of the basin. The lock, which took a long time to fill and empty, was under the control of the miller who made sure that heavy tolls were extracted from bargemasters. It was a considerable inconvenience to barge traffic and particularly so at times of high-water when there was insufficient headroom below the mill floor to allow a barge to pass. The lock was bought by the Thames Commissioners in 1839 and subsequently sold to a private buyer in 1845, who removed it and built a new mill on the site.

The second lock downstream of Abingdon is Clifton and it was built in

1822. For many years it had been recognised that the tortuous path of the river adjacent to Long Wittenham needed improvement and a lock to be sited near Clifton ferry was first suggested in 1793. The matter was raised again in a more vigorous vein in 1811, though a most curious difficulty presented itself to the Thames Commissioners; the piece of land they needed to purchase was owned by a 'lunatic'. However, when they did proceed they built the lock half a mile upstream of the original site suggested, making a cut that by-passed the loop in the river at Long Wittenham.

The three locks, Abingdon, Culham and Clifton completed the improvements the Thames Commissioners made on this particularly winding section of the river between Sandford lock and Burcot. But between the building of Abingdon and Culham lock, Romney lock, sited some fifty-six miles downstream at Windsor (Map 12), was built of oak by the Commissioners in 1798. Leading up to the building of the lock were more than twenty years of hesitancy and uncertainty. The choice of a suitable site and the question whether there was really any need for a lock were the subjects for continued debate. In 1774, the year following the Commissioners' completion of their first series of locks on the river between Sonning and Maidenhead, a lock was proposed upstream of Windsor bridge at the site of a small island. The purpose of the lock was to raise the level of the river and so avoid the frequent fouling of the piers of Windsor bridge by barges, but owing to intense hostility on the part of the residents of Windsor the scheme failed. In 1793 Robert Mylne made an impassioned appeal for a lock to be built as he was concerned about the grim conditions under which barge horses were required to ford the river just above Windsor bridge as they changed from the towing path on one side to the other. The matter of the lock was not, however, reviewed until 1795 when a cut was proposed below Windsor bridge and parallel with the main stream of the river adjacent to Eton College. A weir was proposed at the same time though it was not built until a year after the lock was opened, and it was built in the form of a flash-weir so that the largest barges could continue to use the original navigable stream of the river. This arrangement may have resulted from the difficulties barges encountered as they tried to enter the new Romney lock-cut from Windsor bridge. To improve matters the Commissioners raised the level of the weir, though much to the aggravation of the miller at Clewer, upstream of Windsor bridge, whose mill stream was affected by the raised water level.

*

The newly constructed Kennet and Avon canal opened in 1810 and by way of the river Kennet entered the Thames at Reading. In consequence of the expected additional barge traffic, the City of London Corporation constructed six locks below Staines over the period 1811 to 1815; these constituted the fourth series of locks built on the river and they are described later. The Thames Navigation Commissioners followed the Corporation's lead by building the remaining five (the second group) of the eight aforementioned locks. By doing so, the Thames Commissioners brought about an improvement to the navigation between Cookham and Staines which assisted the additional barge traffic plying between the Kennet and Avon canal and London.

The five locks built by the Thames Commissioners upstream of Staines were the last they were to build on the river with Bell Weir being the first to be built (Map 12). A proposal was made in 1811 for a cut and lock between Milsom's Point and a site almost opposite Ankerwyke House, but the project was squashed by opposition from local residents and the site of the present lock a mile downstream was adopted in 1817. The lock was built during the winter of 1817/18 when the Commissioners purchased the ground on the north side of Charles Bell's garden in the parish of Wraysbury and created a new cut on the south side of the river, adjacent to the existing weir. Of the locks built by the Commissioners it was the furthest downstream and was described by the City of London Corporation as an obstruction to navigation during the first year of its operation. The second of the locks is Old Windsor, which had been discussed as early as 1770 and was to have been sited near Wraysbury. Again, local opposition stopped the project and it was not until 1822 that the lock was built and opened. The site is at the start of a cut that by-passes a loop in the river round Ham Fields and is about three-quarters of a mile upstream from the Bells of Ouseley. The third lock is Cookham and it was proposed in 1787 to remedy the shallow water conditions below Marlow lock (Map 11). It was claimed that one of the most difficult and dangerous places on the river between Reading and Boulter's lock was from Cookham ferry to 'Clifden [Cliveden] Wall'. This section of the river included Hedsor bucks, which in 1775 was described as 'a very dangerous place' as three barges had sunk there. John Rennie commented on the 'large chalk stones that tumble from the clifts above, and lodge in the bottom of the River'. Doubtful of the conditions on the loop of the river between Cookham ferry and Cliveden, the Commissioners prevaricated over the building of a lock, and it was not until 1826 when a barge laden with Bath stone on its way to London foundered at Hedsor and broke in two across the channel that the question of a lock became more urgent. Initially, in 1807, the proposal was for a lock

and cut across the Sashes on the opposite side of the river to Hedsor, and it was this site that was finally chosen in 1829 and the lock (Cookham) was opened the following year. But the building of the lock brought the Commissioners into a vexatious course of litigation with Lord Boston of Hedsor who, in 1832, applied for compensation for the loss of use of his towing path along the original course of the river, which was now deserted of traffic. Before the lock was built, barge traffic used the towing path on the Buckinghamshire bank of the river to the advantage of Lord Boston, but now, barges passed through the lock so avoiding the towing path through his estate. The Commissioners were finally, and it would appear unreasonably, obliged to compensate Lord Boston, though this was not to be their only wrangle with him. At the time the lock cut was made through the Sashes, an ait,[1] which lay in the site of the cut was removed and in common with Romney, Old Windsor and Penton Hook locks, Cookham lock was not provided with a weir and relied upon long adjacent bends of the natural stream to hold a head of water. Nature proved unaccommodating to this scheme and finally a weir was constructed in 1837. This enraged Lord Boston; the lock had deprived him of profits from his towing path and now the weir across what was once the navigable stream blocked access to his wharves at Hedsor. After much recrimination it was agreed that the Commissioners would modify the weir and provide a navigation opening for Lord Boston's benefit, and in consequence of the dispute between the Commissioners and Lord Boston, about half a mile of scenic river, which was once the navigable stream, was closed to the public.

The fourth lock, Boveney, was first proposed in 1780. Between Boveney and Eton there are sharp turns in the river and it was believed that navigation would be improved by a cut and lock, though it was not until 1827 that a decision was made to build the lock in a cut on the opposite side of the river to Surly Hall. Following this decision there were delays while the Commissioners considered various schemes, and it was not until 1836 that they looked at these schemes more seriously. First, at the site of the long forgotten Gill's bucks a pair of low gates was proposed, which would be left open at times of high-water. Secondly, the cut opposite Surly Hall was re-considered and dropped, and finally the present site was chosen just below the village of Boveney. The lock was built between what may have been Lady Capel's ait and the Buckinghamshire bank of the river, and a weir was constructed at the same time. It was opened in 1838 in a not particularly auspicious fashion as the first two boats passing through the lock downstream and the one boat going upstream were grounded at each

1. Ait or eyot: a small island in the river.

end of the lock cut, and were only refloated by drawing and then shutting the weir.

The fifth and final lock is Bray. It was first proposed in 1833 in the belief that the navigation upstream to Boulter's lock would be improved. At the same time it would appear that the fall in water level between Maidenhead bridge and Boveney was considerable, the current very strong and shoals very frequent. But it was not until 1843 that the need for a lock at Bray became pressing, although an unusual procedure was adopted whereby a lock-house was built first on Parton ait (the earlier name of the island was Parting eyot) in 1844 and a lock 'without sides' was built in the following year. In effect, the lock was used in low-water conditions and when the river was full the gates at each end were left open. A situation that does not occur today owing to the greatly improved management of water levels.

As the nineteenth century progressed the decline in trade on the river brought about by the advent of the railways caused the Thames Navigation Commissioners some concern. In 1835 the Great Western Railway Bill received royal assent and a line between London and Maidenhead opened in the summer of 1838. And from this line a network of branch lines began to grow. The Windsor branch was the first, opened in 1849, and others followed: Cookham and Bourne End in 1854, and Marlow much later in 1875; Shiplake and Henley in 1857; Wallingford in 1866; at Didcot the line branched out to Oxford and Abingdon; above Oxford it split at Yarnton and passed through Eynsham on its way to Lechlade and finally Fairford. No method of transportation could possibly have posed a threat to the movement of merchandise along the line of the Thames as did the Great Western Railway. It is however likely to remain debateable whether the difficulties encountered by the Thames Commissioners were caused by the railway alone. Since the mid eighteenth century the Commissioners' endeavours had shown signs of mismanagement and a lack of adequate funding. The Act of 1770 had increased the number of members of the 1751 commission by the addition of clergy from all the riparian parishes and members of parliament who sat for or resided in the seven upper river counties. And even though decisions could be made by a quoram of eleven members, it was, nevertheless, a classic case of too many cooks, and to add to this, management decisions were made difficult as the Commissioners' interests stretched over the length of the river between Cricklade and Staines. But what is most significant is that during the period of the Commissioners' administration from 1751 to 1857, they failed to capitalise on the growth of canal traffic whose logical route to London's docks should

have been by way of the Thames. In the final stage of their administration the Commissioners resorted to desparate measures to combat the railway, but to no avail. Reducing the wages of their lock-keepers and offering inducements to bargemasters in the form of free passage through certain locks at certain times was ineffective, and in any case the situation was aggravated by the increasingly poor state of the river.

THE LOCKS DURING THE PERIOD OF THE
CITY OF LONDON CORPORATION

At the beginning of the nineteenth century the City of London Corporation was under pressure to improve the state of the river below Staines. In 1805, Zachary Allnutt, who was then secretary to the Thames Navigation Commissioners, published his thoughts concerning the improvements he felt were needed and with this document he included a copy of a petition of 6 December 1804 by bargemasters using the river below Staines. They complained about the many shoals and rapid currents that affected the river and they considered the effect of these impediments upon navigation to be 'Difficult, Dangerous, Tedious and very Expensive'. During times of short water the river was often impassable for laden barges drawing three feet ten inches. These were conditions they had at times encountered above Staines, though the conditions had largely been remedied by the efforts of the Thames Navigation Commissioners who had built locks and dredged the river bed. The bargemasters not unreasonably expected the City of London Corporation to act and the Corporation acknowledged that they would need to build locks in order to improve the stretch of river within their jurisdiction. Their proposals eventually resulted in the fourth series of locks on the river, comprising Penton Hook, Chertsey, Shepperton, Sunbury, Molesey and Teddington (Maps 13-14). As early as 1793 a survey for a lock at Chertsey was made by Robert Whitworth, though his proposal was disallowed by Parliament. In 1802 a proposal for a lock at Molesey also failed and it was not until 1805 that John Rennie made new proposals for a lock at Chertsey, Shepperton and Sunbury. His proposal for a lock at Chertsey was radical as it involved making a cut of about 2500 yards on the Surrey side of the river from the southern extremity of Penton Hook to a site near Chertsey bridge and building the lock within the cut. Although his scheme avoided sandbanks in the gulls or narrows at Laleham, the land-owners whose land the cut would cross successfully blocked the scheme. Rennie's proposal for a lock at Shepperton was equally radical involving a

cut of similar length starting from below Chertsey bridge. This proposal met with such formidable opposition that it was promptly dropped. In the same vein he proposed a further cut from the bend in the river at Halliford, to Sunbury, to accommodate the third lock in his overall scheme which, in effect, was a canal of about eight miles commencing at Penton Hook and finishing at Sunbury; but again his proposal was blocked.

Four years later, in 1809, John Rennie introduced a substantially modified proposal that was approved by an Act (George III) of 1810. The Act authorised the building of a lock at Chertsey, Shepperton, Sunbury, Molesey and Teddington. Teddington was the first of this series of locks and it was opened in 1811, and for a little more than eighty years it remained the lowest lock on the river.[1] Its purpose was to overcome the navigational difficulties encountered at Teddington caused by shoals which at times caused as many as twenty barges to be laid up owing to lack of water. Almost as soon as the lock was opened it was damaged by bargemen who later were heavily fined by the City of London Corporation. Possibly as a result of this early damage, the lock needed considerable repairs by 1825.

Sunbury was the second of the series of locks to be opened (1812) and it was built on Sunbury church ait, which was owned by a number of people whose combined interest in the island cost the City of London Corporation a considerable sum of money. A year later a house was built for the lock-keeper, but from the time the lock was opened it caused inconvenience to local people as the old wharf and landing stage near the church were avoided by bargemasters who found it inconvenient to stop because of the siting of the new lock. Instead, they unloaded their merchandise onto the river bank in front of a private residence, much to the

1. When the old London Bridge was replaced in 1832 by the one designed by John Rennie, the high and low tide levels of the river above the bridge were altered and the greatest change took place between Syon Reach and Teddington. At low tide in summer the water levels would at times be as little as eighteen inches. The vestries of Twickenham and Richmond approached the Thames Conservancy on a number of occasions from 1860, but the Conservators were disinclined to do anything to improve the situation. The vestries persevered and proposed a weir across the river below Richmond bridge comprising a number of sluices incorporating buoyancy chambers that could be raised or lowered from an overhead bridge; and they proposed that one side span (on the Surrey side) should contain a lock. The issue was forced by the Richmond Footbridge, Sluice, Lock and Slipway Act (Victoria) of 1890 and the scheme was financed jointly by the Richmond vestry and the Thames Conservancy. The weir maintained the level of the river upstream at low tide, while at high tide the sluices are raised and turned horizontally beneath the bridge allowing vessels to pass through the spans of the bridge. At other times the lock is used. The lock and weir was opened to traffic on 19 May 1894; later, on 1 April 1909 it came under the jurisdiction of the newly formed Port of London Authority.

alarm of the owner who discovered that remonstrating with the bargemen was not a wise course of action. Owing to an increase in the number of smaller barges on the river the lock was fitted with centre gates in 1838, though by 1852 the lock was dilapidated and finally had to be rebuilt in 1856 at the tail of the lock-cut, and at the same time a new house was built for the lock-keeper.

To follow Sunbury lock, the third and fourth locks of the series were built at Shepperton and Chertsey in 1813. The lock at Shepperton was built on a stream known as Stoner's Gut, which cut across the neck of the southward loop in the river at Weybridge. The stream did not become a navigable channel of the river until regular flooding finally made it so in 1774, much to the detriment of navigation to and from the River Wey, for until that time barge traffic was concentrated on the loop of the river connected with the Wey where there was situated a wharf for unloading barges. In the year the lock was built a lock-house was provided at the end of Stoner's Gut, though it is not clear whether the building of the lock and house used the same channel and bank of the Gut, or whether a separate cut alongside the Gut was made. The lock needed extensive repairs in 1825 and in 1829 the lock-house was enlarged so that the keeper could engage an assistant to help with the increase in traffic. At Chertsey, a lock was proposed just above the infall of the Abbey river on the Surrey bank, but Lord Lucan asked that the site be as far removed as possible from his outlook, and in consequence of his wishes an Act (George III) of 1812 authorised the re-siting of the lock below the position initially proposed; by 1854 the lock was worn out.

The two remaining locks of the series are Molesey and Penton Hook and both were opened in 1815. In the case of Molesey lock, building began in 1814 and a lock-house was built in the 'Italianate style' in 1815. All this was to the aggravation of Lady Yonge who complained through another party to the effect that:

> 'The House and Lands were purchased by Lady Yonge at a higher price than the usual value on the account of the advantage and great ornament of the River and the Parklike Grounds on the opposite Shore. Since the erection of the Lock the opposite Shore from being a level Green to the edge of the River and a beautiful Scene of Pasturage is become a Bank raised a considerable height of Gravel, Chalk, etc., with the Lock House overlooking the Lawn and Walks.'

The City of London Corporation did not commence negotiations to buy the land they needed to build Penton Hook lock until after the Act of 1810, and a further Act (George III) of 1814 was needed to give them authorisation to start construction work. In the year of the latter Act, work began on a lock-house before excavation of the lock itself, but when the

excavation work was started there were immediate difficulties caused by flooding of the lock chamber. With the completion of the work, Penton Hook became the highest lock of the series built by the City of London Corporation. And just as other locks in the series caused grievance to certain dignitaries, Penton Hook lock caused aggravation to the tenant of the land extending from the lock to the original course of the river, and he asked for a reduction in his rent as the lock-cut barred his usual path for carting hay and it had become necessary for him to cross the river.

The effect the railways were having on the carriage of merchandise on the river above Staines was not dissimilar to the situation below Staines and the navigation committee of the London Corporation were deeply concerned. Tolls collected from the locks had fallen by half between 1839 and 1849 and it was estimated that by 1850 the permanent charges for administering the locks, and this did not include maintenance, would fall to a level that would make repayment of the principal as required by various Acts, impossible. The only merchandise obtainable at this stage was coal and already the railways were making a sustained effort to claim this for themselves. By 1854 the Corporation's management of the river below Staines had reached a critical point and an appeal to the common council of the Corporation by the navigation committee for urgent funds for maintenance and rebuilding was turned down. This impasse resulted in the Act (Victoria) of 1857 that placed under one authority the powers the City of London had held and exercised for 660 years.

THE LOCKS DURING THE PERIOD OF THE
CONSERVATORS OF THE RIVER THAMES
(THE THAMES CONSERVANCY)

In 1857 the Thames Conservancy was formed by an Act of Parliament with responsibility for the river from Staines to the Nore (the mouth of the Thames), which included the locks from Penton Hook to Teddington. A further Act (1866) transferred the the Thames Navigation Commissioners' administration to the Thames Conservancy, giving the Conservators responsibility for the river from Cricklade in Wiltshire to the Nore.

When the Conservators inherited the locks a large number were in a frightful state of dereliction, a situation brought about by declining barge traffic caused by competition from the railways and consequent loss of tolls. During the penultimate decade of the reign of the Thames Navigation Commissioners the loss of revenue had become so acute that many lock-

keepers had their wages halved and in some instances reduced to nothing, though they were encouraged to stay on and occupy their lock-houses and take for themselves any tolls they collected from pleasure craft.

The state of affairs concerning the functioning of the locks during the transitional period between the Thames Conservancy taking over the responsibility for the river below Staines, and finally the entire river, was in disarray. A number of surveys at that time demonstrated how the good intentions of the Thames Navigation Commissioners had foundered through mismanagement and lack of funds.

Just before the time of the Thames Conservancy Act of 1857, St John's lock, the highest on the river, was 'in a frightful state of dilapidation' with hurdles of straw in place of missing lock gates. It was not repaired until the year following the Thames Navigation Act of 1866, when the Conservators were given access to the river above Staines, though eventually the lock was rebuilt in 1905. In 1867 new gates were fitted to Buscot lock although within ten years they had disappeared owing to misuse and subsequent dilapidation. Rushy lock in 1857 was described as 'in a most frightful state of dilapidation. It had only two gates out of four, and it was stuffed up with hurdles, and straw, and that sort of thing, to keep the water up to a certain height'. Repairs were carried out in 1867 although it was not until about 1898 that the lock was rebuilt. By 1872 Pinkhill lock was in a very ruinous condition and it was partly rebuilt a few years later, while Godstow lock at about the same time was closed for repair as its dilapidated state made it dangerous for boats to pass through. There is nothing recorded to indicate the condition of Osney lock, although in 1859 it was described as very picturesque and a favourite subject with artists, a comment that might easily be interpreted as meaning an unusable state. The two pioneering locks on the river, Iffley and Sandford, appear to have maintained a serviceable condition even though in 1865 there was talk of moving Iffley lock and weir and building a new lock just below Oxford; a proposal that was not taken up and a year later the lock was repaired. Downstream of Sandford lock the state of Abingdon and Clifton locks is not known, but Culham lock was the subject, together with Benson lock, of correspondence in *The Times* (August 1865) concerning the ruinous condition of the locks and one holiday-maker wrote: 'Culham-lock was in such a rotten state that two of the sluices out of four made no impression in emptying the water, and the lock-woman informed us that she did not know to whom to apply to repair it.' And of Benson lock: 'Benson-lock house was deserted, and shut up; the handle [to operate the sluices] hid away, and a great rent all down the upper gates, so that this lock detained us more than 40 minutes.' Day's lock and the locks downstream to Caversham all required attention. In 1865 Day's lock was

described as: 'In utter ruin: how it holds together I do not know. One of the gates is chained up; the weir is also out of repair, and in a very dangerous condition indeed; any flood breaking down one of these upper places may destroy the whole navigation.' Day's was rebuilt in 1871, while the rebuilding of Benson lock preceded it in 1870. The three locks, Cleeve, Goring and Whitchurch, although described by Mylne as bad and ignorantly constructed, survived intact for eighty-seven years and more before re-building became necessary. Cleeve lock was rebuilt in 1874, Goring in 1886 and Whitchurch in 1875. At Mapledurham a new and larger lock was built alongside the original lock in 1908, and Caversham lock was rebuilt in 1875.

In 1865 the Thames Conservators reported the lock and weir at Chalmore Hole as being in a very bad state, though it was not until 1873 that proposals were made for its removal. But they had not reckoned with the inhabitants of Wallingford who petitioned against them over the proposed removal of the lock and the Conservators had to consider the possible repair of the structure. It is unlikely that anything further was done, as in 1881 the lock-keeper was instructed by the Conservators not to take tolls while the lock was in its present state. An independent observer wrote: '. . . the weir is a mere row of rimers and paddles straight across the stream, while the lock as often as not is wide open from end to end.' There followed a further flurry of petitions against the removal of the lock as certain inhabitants of Wallingford were concerned about a possible fall in water level and its effect upon the town. Their petitions were dismissed and the lock was removed in 1883, though the removal was concerned mainly with the gates, and the rest of the structure was left in a ruinous state. In 1889 the ruined lock was an impediment to navigation and by 1895 there were still to be seen two blocks of concrete thought to be part of the head and tail of the lock.

The first series of locks built by the Thames Navigation Commissioners between Sonning and Maidenhead in 1772/73 were all in need of attention. In particular, Hambleden lock was in imminent danger of collapse by 1865 and a comment in *The Times* indicated that it was unusable for more than a week while essential repairs were carried out; but it was not until 1873 that the lock was rebuilt. Hurley lock was in such a bad state by 1860 that the lock-keeper was drowned. Temple lock was described as 'a conglomeration of rotten piles' in 1874 although it was not until 1890 that a new lock was built alongside it, while the site of the old lock was converted to boat rollers. Marlow lock in 1881 was described as 'a dangerous one to pass, being old, with many ragged piles and broken woodwork about its sides'; it was not rebuilt until 1927. The remaining locks of the series were rebuilt over a period of time: Sonning in 1868 and again in 1904, Shiplake in 1874

and Marsh in 1886. Boulter's lock was an exception as a new lock had been built on the Berkshire side of the river adjacent to Ray mill in 1829 (Map 11). The original lock had been built on the Buckinghamshire side of the river near Taplow mill, but in 1826 it was completely worn out and impassable at low water (Map 10). Boat rollers were built alongside the new lock in 1888 but owing to the considerable amount of traffic handled by the lock, it was necessary to rebuild the lock again in 1912.

The group of locks built between 1818 and 1845 (Cookham to Bell Weir) by the Thames Navigation Commissioners were in various states of condition. Cookham lock was lengthened in 1892 and at the same time boat rollers were added, though it was not until 1956/57 that the lock was rebuilt. Bray lock was not used in high water conditions and it was the custom at that time to leave the gates open and no tolls were taken; though in or about 1877 sides were added to the lock chamber, and in 1885 the lock was rebuilt on a new site. Before this date, Charles Dickens had described the lock as 'a rotten and dangerous structure'. In 1898 a new lock was built alongside the original Boveney lock, the latter being used as the site for boat rollers in the same manner as Temple lock. Romney lock was in poor condition by the mid eighteen-sixties and was rebuilt in 1869; and at this time the removal of Old Windsor lock was discussed, though nothing further was done and the lock was finally rebuilt in 1889. Bell Weir, the lowest lock the Thames Commissioners built on the river, was in a very bad state and collapsed in 1866; it was rebuilt with stone the following year.

The remaining locks on the river from Penton Hook to Teddington, built by the City of London Corporation, would appear to have been better maintained, though most were rebuilt and later improved after the turn of the century. The first to be rebuilt was Teddington in 1858 and at the same time a smaller lock was built so that the main lock could be dedicated to barges and other large vessels; Penton Hook was rebuilt in 1875 and enlarged in 1909; Chertsey was rebuilt in 1866 and enlarged in 1913; a new lock was built adjacent to the existing Shepperton lock in 1899, and a new lock was built alongside the existing Sunbury lock in 1926; Molesey was enlarged in 1906.

This summary of the condition of the locks during the very early years of the Thames Conservators' jurisdiction leads to a closer examination of the state of the river and the situation that faced the Conservators immediately following the Act of 1866. Many of the weirs and locks were derelict or in a highly dangerous condition, and the river itself had silted up to such an extent that navigation above Oxford was almost impossible. Shoals had formed in parts of the river causing riverside lands to flood and farmers were often required to construct banks alongside the river to

protect their land and properties. The situation was presented to the Conservators by their Superintendent of the river above Oxford, who undertook to inspect the river from Cricklade to Oxford during November 1866. His inspection was thorough and certain comments he made were most revealing. First, he examined Hannington weir, about seven miles downstream of Cricklade, describing it as a simple fishing weir holding up about two feet of water. The next weir downstream was Inglesham sited a short distance above the junction of the Thames and Severn canal with the river. His recommendation that tolls should be collected from pleasure craft passing through the two weirs is an indication that although they were used primarily to trap fish, they were also flash-weirs suited to the passing of small craft. But the depth of water was insufficient to take commercial traffic, and in any case the line of the Thames and Severn canal, which passed through Cricklade, had removed the necessity for making the river above Inglesham navigable for commercial purposes. The river between the junction of the canal at Inglesham and the wharves at Lechlade was, however, important, as the warehouses there held goods that were transported by barge to Stroud, Gloucester and other places, and a return trade in coal came from the Forest of Dean and Somerset.

The condition of the river below Lechlade left much to be desired and the Superintendent's report was clear on the matter. Even though St John's and Buscot locks were unusable, the former missing some gates, there was limited navigation as far as Radcot bridge, some five and a half miles below Lechlade. This was made possible by using the old flash-weirs adjacent to the two locks as well as Hart's upper or Eaton weir near the village of Kelmscot. Navigation on this stretch of the river benefitted coal merchants at Radcot bridge as well as Robert Campbell who had succeeded Edward Loveden as the owner of Buscot Park and who had a wharf at Eaton Hastings. During the Superintendent's progress downstream he discovered what he not unreasonably thought to be sharp practice on the part of the owner of Buscot Park, whom he found to be extracting water from a well close to Buscot lock cottage using a pump driven by a stream diverted from the main river,[1] and a similar arrangement at Hart's upper weir. He was assured that these were genuine wells and water was not being extracted from the river for the purpose of feeding a reservoir at Buscot Park, but he was not convinced and recommended the Conservators to look more closely at what was going on.

From Radcot bridge downstream to Newbridge, a distance of about ten miles, the river was unnavigable, not only because Rushy lock required new

1. The pump was restored in 1996 and is able to carry out its original function.

gates, but of the need for extensive dredging and the reconstruction of the towing path where it had been displaced by the construction of flood banks. The Superintendent cited two instances of loss of trade resulting from the deplorable state of that part of the river. The first was that of a principal trader on the river who had been invited to tender for a contract to carry on a regular basis 500 tons of coal from Lechlade to Tadpole bridge, the latter about three-and-a-half miles below Radcot bridge; but he could not take up the offer as he was unable to pass his barge over that stretch of the river. The second was that of a farmer who was also a coal merchant and had a wharf at Duxford, about three-and-a-half miles below Tadpole bridge, and could not use his wharf for loading and unloading owing to the state of the river. He believed there was a considerable trade in coal, corn and hay that would more easily be transported by river than by the newly opened railway, which he was obliged to use as the only alternative mode of transport, even though access to the nearest railway station, he claimed, was ruinous to the state of his horses and wagons.

Below Newbridge the river to King's weir, a few miles above Oxford, was partly navigable and allowed the transportation of coal which was essential for the operation of the considerable number of portable steam engines used for agricultural purposes in the area. This river-born trade in coal, mainly from Newbridge, was scarcely affected by the opening of the railway from Yarnton to Fairford by way of Eynsham, Witney and Lechlade. And in addition to the trade in coal there was a flourishing river trade in corn and flour to and from Eynsham.

There were however navigational problems between Eynsham weir and Oxford. Godstow lock and weir required essential repairs and extensive dredging was needed; in fact the river between King's weir and Medley weir was in a dilapidated state and much of the river trade in corn and flour was diverted from just above King's weir to the Oxford canal, re-entering the river between Medley weir and Osney lock (Map 3).

Owing to bad weather conditions the Superintendent's inspection of the river was extended beyond the few days he had initially set aside, and he used the time he was held-up to make additional enquiries on behalf of the Conservators. Before he had embarked on his inspection he had notified the tenants and owners of the old flash-weirs that they were bound by the Thames Navigation Act of 1866 to pay any tolls they collected from 6 August to the Thames Conservancy Board. This came about as the ruinous state of the locks had led to the old flash-weirs in private hands being used so that barges could make some sort of passage up and down the river. The response to his missives was an indication of the total lack of management on the upper navigation during the final years of the Thames Navigation

Commissioners. He found that at St John's weir, tolls had been taken but no account kept; at Buscot weir the keeper allowed him to see his book, which showed he had illegally received forty-one shillings in tolls, but he would not part with the money; at Hart's upper weir the tenant claimed he had received no instructions from the owner and declined to hand over the tolls he had collected. The weirs belonged to Robert Campbell the owner of Buscot Park, and the Superintendent had to remind him of the terms of the Act of 1866 that disentitled him to collect further tolls for himself. At Hart's lower weir, no account of tolls had been kept and no money would be handed over without the sanction of a certain solicitor in Faringdon. The keeper at Harper's weir claimed that no boat had passed since 6 August, and at Old Nan's weir the keeper was not to be found and the surrounding country was flooded owing to his mismanagement of the sluices. At Rushy lock and weir the last laden boat to pass through was on 21 April 1865 and since then the keeper had taken eighteen pence in tolls from pleasure craft. Other weir keepers between Tadpole bridge and Newbridge had not observed the passage of any boat for some time, but at Ridge's weir and Skinner's weir, tolls from canal boats had been collected, and similarly Pinkhill and Eynsham weirs.

At the time the Conservators' Superintendent was inspecting the river above Oxford, two engineers appointed by the Conservators were surveying the river between Oxford and Staines. The purpose of their survey was to put forward proposals that would make the river more easily navigable for future traffic. They reported that the existing defects were chiefly the dilapidated state of the locks and insufficient depth of water over their lower sills, shoals that impeded navigation at various points throughout the length of the river they surveyed, and the defective condition of bridges and river bank at various locations.

The following year the Conservators engaged two civil engineers to report on improvements that were necessary for the purpose of navigation and to relieve Oxford from flooding. The civil engineers' report eventually led to the promotion of a Bill by the Conservators in 1870 to obtain rating powers for the purpose of raising the necessary funds to enable them to deepen the river. This move had the backing of the Oxford colleges and the local board of health, though a committee of landowners presided over by the Duke of Marlborough strongly opposed the scheme and the Conservators were forced to withdraw the rating clauses from the Bill, and the civil engineers' recommendations were not carried out. The Conservators, now obliged to look elsewhere for a source of revenue that would enable them to carry out the necessary work above Oxford,

successfully obtained by the Thames Conservancy Act (Victoria) of 1878, additional payments from the six London water companies for water taken from the river.

The Conservators, now with funds at their disposal, entered upon a scheme of massive improvements to the river above Oxford. First, the old flash-weir at King's was rebuilt and enlarged in 1885 with the original navigation opening replaced by a single pair of gates. Later, many of the old flash-weirs were removed and new locks and weirs constructed at Grafton, Radcot, Shifford and Northmoor, and three new cuts were made near Pinkhill lock, all within the period 1892 to 1898. In addition to these works, extensive dredging was undertaken with the result that navigation was improved and the regulation of water, and hence control of flooding, was greatly improved. In effect, the Conservators had more or less implemented the necessary improvements to the river that had been proposed to the Thames Navigation Commissioners by Robert Mylne in 1791. The result of the improvements to the river above Oxford and as far as the junction of the river with the Thames and Severn canal at Inglesham, was a navigable depth for barges drawing four feet of water. However, by the end of the nineteenth century the Thames and Severn canal was in a poor state of repair, and in 1900 it became the responsibilty of the Gloucestershire County Council who carried out work to the summit level and reopened the canal in 1904. Unfortunately, the work done by the Conservators to improve the upper river and the efforts of the Gloucestershire County Council was to no avail, and their combined efforts failed to promote sufficient commercial traffic with the result that the canal was finally closed in 1927.

Almost thirty years elapsed before the Conservators were moved to consider further improvements to the river above Oxford. The principal navigational difficulties were the old flash-weirs at Eynsham, King's and Medley, all within a six mile stretch of the river above Oxford. Not only were they a great inconvenience because of the necessity to draw down water from the level above each weir to the level below in order to pass a vessel, but in doing so water was wasted and low-lying riverside land frequently flooded. At times when a strong stream was flowing, each of these flash-weirs could present danger to vessels attempting to pass through. The Conservators decided therefore upon the following scheme: they would construct locks and cuts at Eynsham and King's; rebuild and at the same time deepen Godstow lock; and finally remove the entire structure of Medley weir, thereby creating a continuous stretch of river between Godstow and Osney lock. The scheme of work was the last major improvement to navigation on the river that involved creating new locks and the stages of the improvements warrant closer examination.

The history of Eynsham weir dates back many centuries to the time when it was owned by the Abbey of Eynsham, though by the latter part of the eighteenth century the owner was Lord Abingdon. In 1795 it was decayed and did not hold up any water, nor had it done so for some years. No doubt repairs were undertaken by Lord Abingdon for in 1802 Robert Mylne commented on the amount of water lost when the weir was used for navigation purposes. Mylne pointed out that when he passed through the weir by boat that year, the level of the reach between the weir and Pinkhill lock, about a mile and a half upstream, was reduced by eight inches, and this represented a substantial quantity of water compared with the amount used by a lock. During the first half of the nineteenth century the decline in barge traffic on the river and consequent loss of tolls resulted in the weir being derelict by the time it was vested in the Thames Conservators by the Act of 1866. Twenty years later, in 1886, the Conservators in agreement with the Thames Valley Drainage Commissioners removed the weir and built a new flash-weir 100 yards above the site of the old weir. This formed the navigation passage for river traffic until 1927 when Eynsham lock was built.

As part of the Conservators' scheme, the deepening of Godstow lock became essential by 1924 as the depth of water above the lower sill of the lock was often no more than twenty-eight inches at times of low water, and this was insufficient for navigation purposes. Dropping the lower sill required re-building the lock, and when the work was completed in 1924 the depth of water above the lower sill in low water conditions was increased to forty-six inches. This provided the required margin of safety for navigation purposes not only during periods of low water, but in anticipation of the eventual removal of Medley weir, which would lower the level of the river below Godstow lock.

The removal of Medley weir had first been proposed by the Conservators as early as 1883 when the City of Oxford had been the subject of a flood inquiry. It was believed at the time that the removal of the weir would benefit the city, though owing to difficulties raising the necessary funds the proposal was abandoned and it was not until 1926 that the Conservators were in a position to carry out the necessary work, which not only involved the removal of Medley weir but the deepening of the river adjacent to Port Meadow on the Oxfordshire bank between Godstow lock and the site of the weir. This undertaking required steam dredgers that over a period of two years removed about 45,000 tons of material from the river bed. On completion of the work in about 1928 the stretch of river above Oxford had only one flash-weir remaining, at Kelmscot, and that was Hart's upper or Eaton weir.

Although Eaton weir was the last flash-weir in the navigation channel,

the old flash-weir at King's remained intact, even though the navigation channel now passed through the newly constructed lock. In 1929 plans were prepared for repair work to the gates forming the navigation opening of the weir and in the same year the weir itself was reconstructed. It may be that the Conservators had in mind using the flash-weir in times of maintenance work to King's lock, but what is more likely is that the sluices in the pair of gates were used to supplement the adjoining section of weir, which in itself was not extensive. At the time repairs to the gates and the reconstruction of the weir were carried out, the single pair of gates were to the left of the weir looking upstream, while adjacent to the gates were boat rollers. Today, the gates have long been removed and in their place are paddles that act as a sluice. At Eynsham a similar situation applied and when the new lock was constructed in 1927, the navigation opening in the old flash-weir was left intact and used to supplement the other part of the weir by using the paddles as a sluice; an arrangement that prevailed until 1950 when the entire weir was reconstructed.

The completion of King's and Eynsham locks in 1928 ended the improvements carried out on the river in terms of the construction of entirely new locks; the first locks built about 1630 at Iffley and Sandford and the aforementioned locks built in 1927/28 marked the beginning and end of almost 300 years of improvement, a period during which the river was transformed from a partly navigable waterway into a fully operational system of locks and weirs that not only provided a safe and efficient way of passing commercial traffic over 124 miles, but at the same time brought about control of the flow of the river with its attendant benefits to riparian landowners whose pastures and meadows had in earlier years been flooded. This does not mean to say that the Thames Conservators were now in a position to sit back and bask in the pleasure of their achievements. From 1928 onward there was a continuing programme of work to improve the locks and weirs and the most important was the gradual removal of the traditional balance beams from the lock gates between Oxford and Teddington and their replacement with electrical and latterly hydraulic control of the movement of the gates and sluices. The first lock that underwent this change was Mapledurham, which had electrical control of the gates and sluices installed during the winter of 1955/56. The same changes were made to Cookham lock in June 1956 and Old Windsor lock in 1957. But the Conservators proceeded no further for two reasons: first, the gates and sluices were operated from a control panel in the lock-keeper's hut and from his operating position he did not have a clear view of the movement of small craft within the lock chamber when it was empty, clearly an unsatisfactory situation in terms of safety; secondly, it was evident at the

time that the movement of large masses by hydraulic control was the most attractive technology for operating the locks. With this in mind, plans were prepared for an all hydraulic system for the future operation of the locks and the first lock to be modified was Shiplake in November 1960. Work continued on other locks during the nineteen-sixties and the last lock to be modified in the decade was Godstow in November 1969. A gap of a few years followed before Mapledurham and Cookham lock were modified from the earlier electrical control to hydraulic control in October of 1973 and 1974 respectively. The third lock using electrical control, Old Windsor, was changed to hydraulic control much earlier in 1965. The hydraulic system is worked by hand operated controls mounted on a pedestal adjacent to each pair of gates and on the side of the lock occupied by the keeper's hut. From these positions the keeper has a clear view of the lock chamber. When the keeper is working normal hours of duty the master hydraulic pump is operating, but when the keeper is not on duty and the public are permitted to operate the lock, a wheel has to be turned to operate a secondary hydraulic pump which produces sufficient hydraulic power to open and close the gates and sluices.

The volume of merchandise conveyed on the river had reached a peak in the latter years of the Second World War and with the exception of a peak in volume during the early nineteen-fifties, the decline in commercial traffic accelerated in the latter nineteen-sixties and reached the lowest figure recorded in 1972. Even though the demise of commercial traffic on the river was brought about by the rapidly increasing trend toward road transport, the loss was quickly being replaced by the movement of pleasure traffic on the river, which had increased rapidly since 1945. This was the principal reason for the application of modern engineering to the locks in the post-war years; it was to enable the rapid passage of large numbers of small vessels from one section of the river to the next. The chief engineer for the Thames Conservancy was well aware that the way to handle large numbers of small craft passing through the locks was to improve the efficiency of the filling and emptying process and to this end the reconstruction of Sandford lock in 1972/73 was a major step forward in lock design.

Sandford lock was one of the first locks built on the river. The original lock was replaced by a new lock built alongside it in 1836, and it was this lock that the Conservators singled out for radical reconstruction in 1972. The structure of the lock had given cause for concern for some time and it was pumped dry in February 1969 so that repair work in the area of the tail gates could be carried out. On inspection it was seen that the main body of the lock below standard tail water level comprised exposed timber piling in

a deteriorated condition. The areas of the head and tail gates were built of masonry patched with brick and the floor and aprons comprised concrete in variable condition together with old timbers. Repair work was considered impracticable and a new lock the only realistic solution. It was built on the centre line of the existing lock, though the width was increased and the length extended in the upstream direction. The major feature of the new lock was the use of an underfloor filling system instead of the traditional method of filling through sluices in the head gates. One year later Bell Weir lock was reconstructed on the same lines as Sandford lock, though an improved arrangement of the ducts and outlets for the underfloor system was adopted.

Further rebuilding programmes came into effect following the dissolution of the Thames Conservancy in 1974, but the Conservancy had set the standards for future lock construction and what they had achieved during the rebuilding of Sandford lock was carried forward and improved upon by the new administrations. Romney lock was rebuilt in 1979/80, and most recently Hambleden lock was rebuilt in 1993/94 using the most advanced forms of lock construction.

3

LOCK-KEEPING DURING THE PERIOD OF THE OXFORD COMMISSIONERS, THE THAMES NAVIGATION COMMISSIONERS AND THE CITY OF LONDON CORPORATION

Little is recorded about the keepers who looked after the first locks on the river, that is, Iffley, Sandford and the lock in the Swift Ditch. The keeper at Iffley lock may have been the miller or his assistant at Iffley mill, and further downstream at Sandford the keeper of the inn below the lock, or the miller whose mill was a short distance from the inn. It would appear there was an agreement in 1652 between the Oxford Commissioners and another party that a cottage with two rooms should be built adjacent to the lock in the Swift Ditch. The keeper had to be a single man and he would lose his job if he married; he was not to use the lock house for the provision of victuals, nor was he to open the gates of the lock purposely to create a flash of water to assist a barge stranded in a shallow stretch below the lock. There is little doubt that as a regular form of employment, lock-keeping did not begin to take shape until the period of the Thames Navigation Commissioners, though even then there is evidence of lock-keepers who had other forms of employment to support them. This was certainly the case at Iffley lock where the owner or tenant of Iffley mill was also the lock-keeper from 1767 to 1789.

With the formation of the Thames Navigation Commissioners in 1751 there followed a period before they obtained the important Act of 1770 that enabled them to proceed with the necessary improvements to the river, the most important issue being the construction of locks. By 1774 they were concerned with the provision of small wooden houses for the keepers they engaged to operate the locks, but they were not residential and their form was closer to the wooden office that is a feature of the locks today. In 1778 the Caversham lock-keeper's small wooden house was described as a place

to keep the tolls he collected and the tools he needed to open and close the lock. Soon it became clear that small brick built houses would need to be provided for the keepers, though the principal difficulty the Thames Commissioners encountered was persuading landowners to sell the necessary sites for the houses to be built upon.

Even though a lock-house was built at Boulter's in 1774, very little else happened until 1796 when the Commissioners resolved to build brick houses at all the locks and furthermore compel the keepers to live in them. This had become necessary as during the time of construction of the locks from 1772, the men the Commissioners engaged as keepers did not always work in a manner conducive to the Commissioners' needs. The men often had other work and they would neglect the operation of the lock in favour of that work, which may have been their principal occupation. Though the Commissioners did not at first realise the dual role many of their lock-keepers pursued, the situation was made clear to them by their surveyor, Robert Mylne, who saw that the efficient management of each lock depended upon the keeper dedicating his time solely to his lock.

Notwithstanding the good intentions of the Commissioners the plan to have a keeper with a house at each lock had still to be fully implemented. In 1802 Robert Mylne continued to insist that a keeper with his own house should be the arrangement for every lock, and yet by 1816 a satisfactory conclusion had not been reached and to underline the situation, a deputation of the City of London Corporation, making a grand tour of the Thames and certain canals, claimed that some Thames lock-keepers were not always in attendance. Whether the findings of the deputation fuelled the fire started by Robert Mylne is unknown, but in 1821 the Commissioners drew up more positive terms of employment for their keepers, insisting that it was the duty of each keeper to reside at the lock and to open and shut the gates, as well as collect tolls from vessels passing through the lock. The keepers were also required to ensure that the lading of barges was not violated. For all this work the keepers were paid on a monthly basis. Seven years later, in 1828, the Commissioners embellished the terms of employment for their lock-keepers: the keepers were expected to keep watch for an approaching barge and to have the appropriate lock gates open, and while the barge was made fast in the lock the keeper was required to collect the toll before the barge continued on its journey. Other instructions were given concerning the operation of the sluices and it was pointed out to the keepers that only they should operate the lock.

The lock-keepers the Commissioners engaged were not always reliable, though there were a number of exceptions. The keeper appointed to Boulter's lock in 1773 did not retire until 1829 having given the

Commissioners fifty-six years of 'honest and meritorious service'. When he had been appointed it was at a weekly wage of six shillings a week, and this did not change until 1811 when his wage was increased to four pounds a month 'in consideration of his accuracy in his Accounts and general good behaviour'. And three years later his wage was raised to five pounds a month 'in consideration of his long and faithfull services' Similarly, the keeper appointed to Marlow lock the year it was built (1773) continued to work the lock until he died in 1811. His wage had been five shillings and six pence a week until 1803 when it was raised to forty-five shillings and six pence a month. The keeper appointed to Hambleden lock four years after the lock had been built (1773), worked the lock until 1822 when at the age of seventy-eight he retired, handing the management of the lock to his son.

The job of lock-keeping during the period of the first series of locks the Commissioners built (1772/73) was not without its hazzards as the locks had no footboards attached to the gates. Inevitably there were accidents and one winter the keeper of Sonning fell into the lock and was drowned. In spite of various accidents the state of the locks did not improve in terms of safety, and as late as 1860 the sides of Hurley lock were in such a bad state that the lock-keeper's wife nearly drowned; nine years later the Hurley keeper slipped and drowned during one of the notorious winter months when icing created additional hazzards during the filling and emptying of the lock.

In 1798 the keepers working the locks above Oxford expressed their dissatisfaction over the low rates of pay they received, and accordingly a new pay structure was generated that compared favourably with the earliest known register of payments drawn up in 1793. Although the new rates of pay were an improvement for the keepers above Oxford, they received only half the average sum paid to the keepers working below Oxford; a not unreasonable arrangement in view of the disproportionate amount of work required of the keepers in the upper and lower sections of the river.

Even though the Commissioners at first prospered from the revenue they collected from barge traffic, irregularities over the collection of tolls were not unknown. The keeper of Temple lock absconded in 1783 with the takings, and almost twenty years later the keeper of Hurley lock disappeared with almost forty-five pounds in tolls. In 1824 the keeper of Old Windsor lock was dismissed because of irregularities and some years later the replacement keeper fell behind with his accounts. The small income derived from pleasure craft passing through the locks was kept by the keepers as compensation for the extra labour involved, an arrangement that did not last long and by the end of 1830 tolls from pleasure craft had to be taken into account together with the tolls from commercial traffic. No doubt the

keepers were aggrieved by this new procedure and soon it became evident that tolls, particularly in the upper section of the river, were not being collected with the degree of accuracy the Commissioners would reasonably have expected. In fact, the Commissioners quickly came to the conclusion that they were being defrauded by the lock-keepers. It was established that barges in no small numbers accounted for at certain locks, were unaccounted for at others, and the practice of failing to collect tolls was not just a few isolated instances. The Commissioners argued that in view of the fraud and negligence which had come to their attention over a period of time and the resulting loss of revenue, it was not unreasonable to conclude that over many years the losses were frightful. But the Commissioners had no clear idea in their minds how to remedy the situation, though they agreed that the locks above Oxford should be singled out for attention as that section of the river saw only occasional visits by their general receiver. Some years later they decided to auction the letting of certain locks below Oxford to the highest bidder, an arrangement which would require the successful bidder to pay the Commissioners a fixed annual rent. In this way the Commissioners were absolved from the problems of collecting tolls and instead they would receive a regular annual income from their tenants. The tenants renting the locks would be required to man them themselves or engage keepers, collect tolls and hope that at the end of each year there was a financial gain in their favour after they had paid the Commissioners the annual rent. This arrangement was carried out at Iffley and Sandford locks, though it turned out to be unsatisfactory as the Commissioners' tenants in some instances found it difficult to make ends meet. The Commissioners contemplated letting further locks between Abingdon and Caversham, though the matter was allowed to drop in 1864 when Iffley and Sandford locks were re-offered at auction and failed to reach their reserve.

Before the Thames Conservancy took over the administration of the river from the Thames Navigation Commissioners and the City of London Corporation, the Thames Commissioners were responsible for only those locks from St John's to Bell Weir. The small number of locks from Penton Hook to Teddington came under the jurisdiction of the City of London Corporation and the lock-keepers were employed by the Corporation. The Corporation was more authoritative than the Commissioners concerning the rules its lock-keepers were to work to, and in 1815, six years earlier than the Commissioners had drawn up terms of employment for their own keepers, the Corporation made it clear that its keepers were to be constantly in residence in the houses provided for them and be ready to pass vessels at all times through the locks. They were to make sure that no vessel remained in the lock or the lock-cut any longer than was absolutely

necessary, and they were to collect the tolls authorised in the table of charges. They were required to keep a strict account of the collected tolls in a proper book and keep an account of all vessels passing through the lock in an upstream and downstream direction. The Corporation also required the keepers to ensure the locks were not damaged, and in times of frost to keep the lower gates and the sluices of the upper gates open, and to break and remove ice from the lock and lock-cut whenever possible. Finally, the keepers were required to consult the several Acts of Parliament that gave them guidance in the execution of their duties. Some of the men who served on the committee that determined the rules for the Corporation lock-keepers were affluent or held responsible appointments, but this did not stop them from being afloat on the river at four or five o'clock on a summer morning to see that their rules were being obeyed.

In 1821 there were indications of mismanagement concerning the way the accumulation of tolls were collected from the lock-keepers. The two inspectors engaged by the Corporation were not always to be found in their respective districts of the river, and though they visited the lock-keepers once a week to collect the tolls, they seldom collected the precise amount. This did not necessarily imply fraud, as it would appear that all the tolls were ultimately received, but it did mean that the tolls were being manipulated by arrangement between the keepers and inspectors, possibly to the detriment of the Corporation.

Some years later the keepers not unreasonably made an application to the Corporation for improvements to their terms of employment, and in 1833 they petitioned for a regular allowance of coal and candles, while at the same time they were anxious to deny the impression that they received presents of coal from the bargees passing through the locks. It was the damp situation of their houses that made their petition necessary, but the Corporation was unmoved and probably not for the first time the keepers' request was refused.

During the eighteen-forties the era of the railways was beginning to have its effect on barge traffic, and this resulted in a reduction in the annual tolls taken at the locks. By 1850 the Thames Navigation Commissioners found themselves in a serious financial position and by reducing the tolls they believed they would rejuvenate barge traffic. In addition to a reduction in tolls they made the passage for barges through Abingdon and Old Windosr locks free throughout the year of 1851. A spate of economies followed and the most serious for the lock-keepers was the decision in 1852 to reduce their wages. This affected the keepers in different ways: at Abingdon, Cookham and Boulter's the keepers' wages were cut by almost ten per cent, while at Cleeve, Goring, Whitchurch and Mapledurham the keepers' wages

were halved; but they were allowed to keep any tolls they collected from pleasure craft. Two years later the keeper at Caversham lock lost his monthly wage altogether, and he was offered continuing occupancy of the lock-house and any tolls he collected from pleasure craft as an inducement to carry out his duties.

This was a period of crisis for the lock-keepers; not only those engaged by the Thames Navigation Commissioners, but also those engaged by the City of London Corporation. The railways were causing serious damage to the traditional ways of carrying goods by water, and with the falling revenue matters went from bad to worse as maintenance of the locks and weirs fell behind.

LOCK-KEEPING DURING THE PERIOD OF THE CONSERVATORS OF THE RIVER THAMES

With the Thames Conservancy Act of 1857, the City of London Corporation keepers operating the locks from Penton Hook to Teddington came under the administration of the newly appointed Conservators, and some years later the Thames Navigation Act of 1866 brought about the disbandment of the Thames Navigation Commissioners, and the lock-keepers from Lechlade to Teddington came under the one administration. While in principle this offered the lock-keepers a new future and hopefully a new career structure, in practice it was to be a very slow process. Not until the winter of 1910/11 were the conditions the lock-keepers worked under investigated by a sub-committee appointed by the Conservators. The members of the sub-committee visited each lock, weir and ferry on the river and talked to the keepers and ferrymen to determine whether they were satisfied with their conditions of work. With only a few exceptions the keepers stated that they found it difficult to live on the low wage they received from the Conservators. Some of the keepers received a pension from the Royal Navy and they claimed the pension barely made up for the shortfall between their keeper's wage and their annual living costs. The keeper of Rushy lock rented the house he lived in for forty pounds a year, while his Conservancy wage was only thirty-five pounds a year. Over a period of a number of years he had supplemented his wage with his savings, and to add to his difficulties he had to travel five miles to do his shopping. At Northmoor lock the keeper, who had been a carpenter, requested that the Conservators help him build a shed so that he could earn extra money by his former trade at times when he had no duties to perform at the lock.

Although the sale of refreshments was an additional source of income for some keepers, it did not apply to all. The keeper of Godstow lock was prohibited from selling refreshments, while the keeper of Iffley lock claimed he had no time to sell refreshments owing to the many boats from the Oxford colleges he had to pass through the lock. At Sandford lock, the keeper had prepared a statement for the sub-committee showing how his wage was spent; and at Abingdon, the next lock downstream, the keeper pointed out to the sub-committee that he had to attend to the ferry in addition to his duties as keeper. Neither keeper was able to make anything extra from the sale of refreshments owing to the number of nearby shops and an inn, and to add to the difficulties of the Abingdon keeper, the lock-house required attention; the drinking water supply was bad and in times of flood he had to vacate the house altogether. At Culham lock the keeper had several weirs to attend, which kept him away from the lock a few hours each day, and he suffered a problem similar to that of the Abingdon keeper; his water supply was so bad it soiled the clothes that were washed in it. For his nearest source of fresh water he had to walk a quarter of a mile from his house.

At other locks between Oxford and Reading the sub-committee found mixed fortunes among the keepers. At Clifton lock the keeper had his clothes provided by his son-in-law as he could not manage on his wage, which had been eroded over a period of eighteen years by doctors' bills. The Day's lock-keeper tried to be enterprising by renting two acres of land from the Conservators, which he then let to campers; but the venture was not profitable. The keeper of Goring lock who kept a boat for hire told the sub-committee that he found it more difficult to live on his wage now, than when he entered the Conservators' service in 1888, and to add to his difficulties his right of way to the lock was being threatened by the local authority, a situation that had befallen the keeper of Whitchurch lock. The sub-committee found a more agreeable situation at Mapledurham lock where the keeper expressed himself as satisfied, mainly because he had work to do in his spare time making oars and sculls for the Conservators. But at Caversham lock the keeper claimed that he would not be able to marry on the wage he received, and that he was too close to the town of Reading to profit from the sale of refreshments.

The sub-committee noted that the lock-keepers below Reading had an additional reason for wanting a better wage. The passage of barges, often at night, which plied between the Kennet and Avon canal and the tidal reaches of the river, added to their hours of work. The keeper of Sonning lock complained of the extra night work, particularly as barges would often pass through the lock singly rather than in pairs. At Shiplake lock the keeper

50

The Thames at Inglesham looking up stream. Dead centre of picture is where the Thames and Severn canal once entered the river. Left of centre among the trees is the old Roundhouse at the site of the last lock on the canal. *(Photo: the author)*

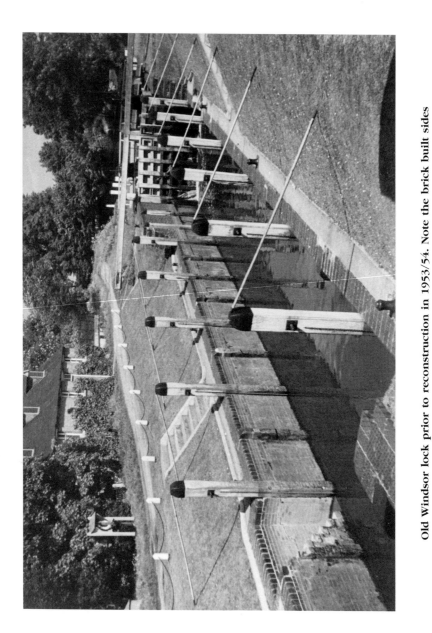

Old Windsor lock prior to reconstruction in 1953/54. Note the brick built sides and timber piles restrained by land ties. This was the reconstructed lock of 1889.
(Photo: the Environment Agency)

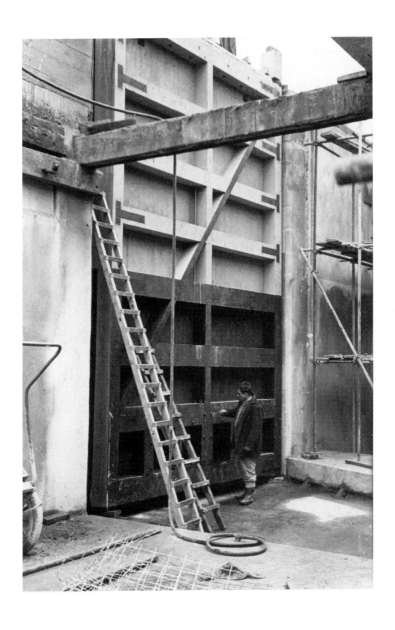

One of the tail gates of Old Windsor lock at the final stage of reconstruction in 1954. Note the sluices at the base of the gate.
(Photo: the Environment Agency)

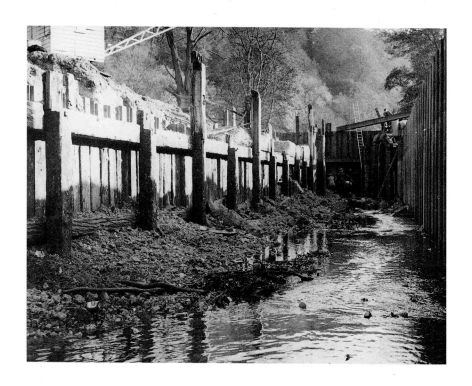

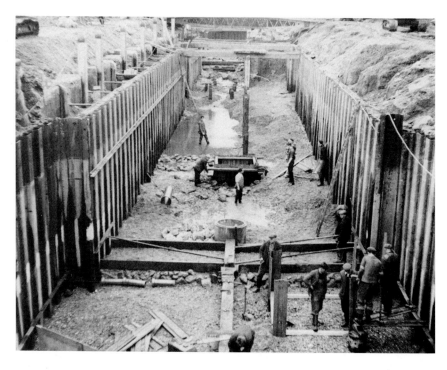

Reconstruction of Cookham lock 1956/57. From top left: excavation of the old lock chamber; construction work within the cofferdam of the new chamber;

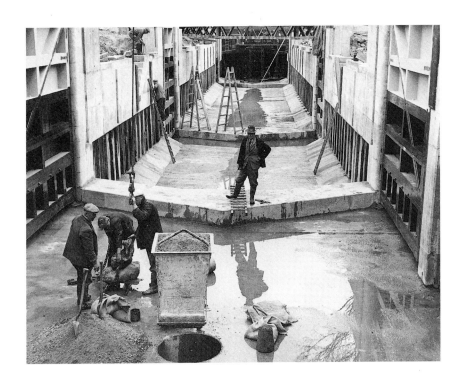

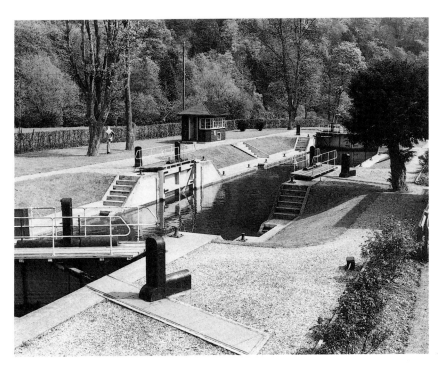

final stage of contruction with the gate sills in place - note the sluices in the base of each head gate; the completed lock looking down stream with Cliveden woods in the background. *(Photos: the Environment Agency)*

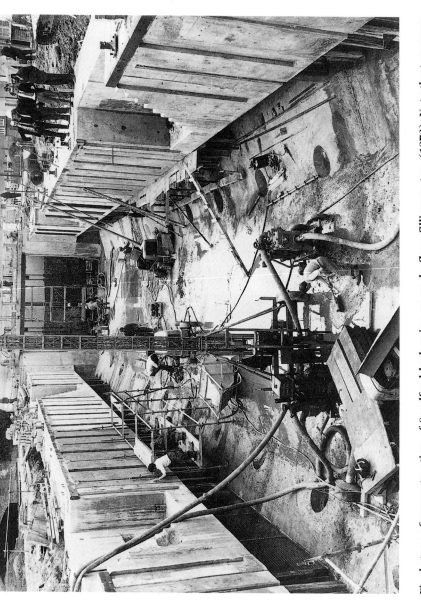

Final stage of reconstruction of Sandford lock using an underfloor filling system (1973). Note the two rows of outlets, one each side of the floor of the lock chamber. *(Photo: the Environment Agency)*

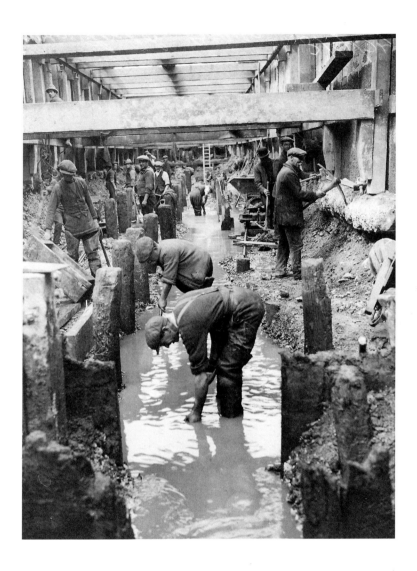

Excavation of Marlow lock in 1927. The timber piles in the floor of the chamber are part of the reconstructed lock of 1825.
(Photo: the Environment Agency)

A Salter's steamer in Boulter's lock - a Sunday afternoon in 1957.
(Photo: the author)

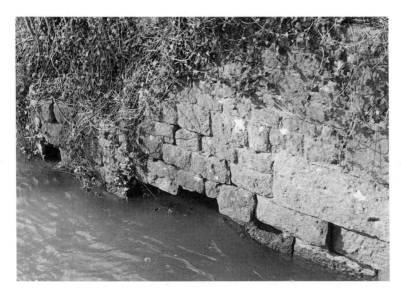

Part of the tail wall in 1998 of the derelict lock in the Swift Ditch. Although Thacker remarked upon the good condition of the stonework in 1910, the intervening years have shown a marked deterioration. *(Photo: the author)*

claimed he could not live on his Conservancy wage alone and it required his Royal Navy pension as well as the profit he made from Shiplake lock island, which he rented from the City of London Corporation and then sub-let, to enable him to make ends meet. Not only did the Marsh lock-keeper suffer from the same night traffic as the preceding locks, but in addition he had weirs to attend and in the winter the work was particularly heavy; and during times of flood his house was affected. The Conservancy wage was barely sufficient to enable the Hambleden lock-keeper to maintain himself and his family, and he also suffered in times of flood when water penetrated under the floorboards of his house.

The Henley Regatta was a cause of extra work for the keepers of the locks above Boulter's, as during the period of the regatta many skiffs were hired in the area of Maidenhead and taken upstream to the event; and in addition the keeper of Cookham lock, who was also the middle ferryman, had boat rollers adjacent to the lock to attend.[1] The next lock downstream, Boulter's, was very busy in the summer months and even though the keeper received an average of seven shillings a week in tips, he expressed to the sub-committee his dissatisfaction with the wage he received in view of the heavy duties he had to perform. All the lock-keepers downstream to Teddington complained of their wage in view of the night traffic on the river, and in some instances extra duties added to the work-load of certain keepers. At Romney lock the keeper pointed out to the sub-committee that his work was harder than when he had first entered the service of the Conservators, while the Penton Hook keeper had a guage weir to maintain as well as give advice to the Water Board. Surprisingly, the Chertsey lock-keeper stated his complete satisfaction with his wage and conditions of service, while his colleague at the next lock downstream, Shepperton, also had no complaint. But the assistant keepers at the two lowest locks gave conflicting views. The assistant at Molesey lock told the sub-committee that when he married in a year's time he would be compelled to find other work unless his wage was increased. His present conditions of employment as a single man were far from satisfactory as there was no alternative to the accommodation in the form of a hut provided for him on the side of the lock. At Teddington lock the five assistants were satisfied with their wage, though the chief assistant was in considerable difficulty owing to the size of his family, which comprised eight children.

The members of the sub-committee retired to consider all that had been put before them by the lock-keepers, assistants and ferrymen. There was the

1. There were three ferries at Cookham; the upper, middle and lower. The latter was known as My Lady ferry.

matter of inadequate or a complete lack of fresh water at a number of the locks. Suggestions had been put forward by a number of keepers regarding an improvement in holidays, and many keepers had proposed a supply of clothing to wear during their working hours. As a result of their deliberations, the sub-committee's recommendation to the Conservators was for an increase in the wage of certain keepers whose work was particularly heavy, and a new scale of pay for all the lock staff and ferrymen. The keeper of St John's and Buscot locks was provided with a bicycle to make his journey between the locks more easy, and the provision of working clothing including a uniform was recommended. Another recommendation put to the Conservators by the sub-committee was the appointment of a doctor for each section of the river who would consult with the Conservators' medical officer in cases of illness among the lock staff. And the matter of employing men who already had a pension was raised owing to the current arrangement of an age limit of forty years for new appointments. The proposal was that this should be extended to forty-five years and as far as it was practicable, any vacancy above Oxford should be filled by a man of middle-age who was in possession of a pension and would therefore be not entirely dependent upon the wage offered by the Conservators. This recommendation was made on the basis that the locks above Oxford were less used than those further downstream and hence younger, fitter men were less essential.

All the recommendations made by the sub-committee went to the Finance and General Purpose Committee of the Conservancy in October 1911. A month later a new sub-committee was formed to deal with the appointment of lock-keepers and other matters concerning the lock staff; it was called the Lock-Keepers' Sub-Committee. In March 1914 the name of the committee was changed to the Lock Staff Special Committee and a year later a lock gardens special committee was formed to encourage the keepers to maintain the gardens on the lock sides, and prizes were awarded. When the lock gardens special committee was formed, the Sir Reginald Hanson Challenge Cup, awarded annually for the best kept lock garden, had already been instituted earlier in 1904, and its continued award was unaffected.

By June 1916, and owing to the efforts of the Lock Staff Special Committee, the permanent staff among the lock-keepers, weir-keepers and ferrymen were in almost every instance provided with a house by the Conservators, but temporary staff were required to find their own accommodation.

*

Even though by 1911 the Conservators had acknowledged the importance of maintaining a good lock staff, the conditions the lock-keepers, weir-keepers and ferrymen worked under were by no means easy, and even with a revised scale of pay their income was comparatively small. The job of lock-keeping could be dangerous and accidents and death were not uncommon. In the winter of 1910/11 the keeper of Radcot lock was drowned during a period of flooding, and his replacement, who had already lost two sons by drowning when he was at Lechlade, lost his wife by drowning during the winter of 1911/12. The Conservators, aware of these incidents, arranged in 1911 that the lock staff receive demonstrations and instruction from the Royal Life Saving Society. The demonstrations included the latest methods of life saving and resuscitation, and the secretary of the Society reported to the Conservators that while he found the lock staff keenly interested, not all the men ventured to be included in the demonstrations and methods of resuscitation. Nevertheless, certain keepers eventually held the Certificate of the Society. The demonstrations were not to be an annual event however, and it was not until 1923 that the Conservators approached the Society about further instruction for their lock staff.

The review of working conditions and procedures undertaken by the Conservators' sub-committee and the formation of the Lock Staff Special Committee were the beginning of the profession of lock-keeping as it is known today. Following the First World War more service personnel took to the profession of lock-keeper. The keepers appointed had in a number of instances held responsible positions in the Royal Navy, including Chief Petty Officer, Petty Officer and at least one Chief Yeoman of Signals. As the style of person appointed to the position of lock-keeper changed, so the number of disciplinary hearings in connection with indiscretions or lack of application to duty by keepers diminished. At the same time, the keepers became more aware of matters relating to their pay and conditions of employment. Owing to the increased cost of living at the conclusion of the First World War, the keepers had reached a stage where their wages no longer equated with their outgoings, and though the lock staff were offered War Bonuses to cover the deficit, they were well aware that they were still underpayed in view of the workload they carried. Because of this state of affairs an agreement was reached in February 1920 for an increase in their wages.

Seven years elapsed before the lock staff and ferrymen made another application to the Lock Staff Special Committee for a wage increase. Even though their application was granted, the time had come for a general review of lock staff pay and conditions of service. The new proposals

became effective in October 1929 and included the lock, weir and ferry staff, whose pay until that time had been supplemented since October 1920 by a bonus scheme based on the cost of living figure published in the Ministry of Labour's Gazette. The bonus paid to the staff during the nineteen-twenties had fluctuated with a general downward trend as the decade progressed. On 1 October 1929 the bonus was abolished and the new rates of pay gave the lock-keepers an average wage of thirty-nine shillings a week in the upper district of the river (St John's lock to Bell Weir lock) and an average of forty-eight shillings a week for the lower district (Penton Hook lock to Teddington lock); the ferrymen received an average wage of thirty-three shillings a week. In addition to the new wage structure a revision of the leave granted to the lock staff was made. The existing arrangement of seven days leave and one extra day for each month making nineteen days a year, was increased by seven days with the understanding that the one day given for each month must be taken and not accumulated. At this time, the lock, weir and ferry staff numbered sixty-five and they did not rest on Bank holidays, Saturday afternoons and Sundays. The hours they worked remained long and arduous in the summer months and though their duties lightened in the winter months, the regulation of weirs adjacent to the locks required much of their time.

During the nineteen-twenties and thirties the volume of merchandise conveyed through the locks did not change greatly with each year. The number of pleasure craft registered on the river did show a slight downward trend, though the number of launches on the river increased during the period 1932 to 1939. But the number of hours registered pleasure craft used the river was increasing rapidly owing to the availability of lock passes at a greatly reduced rate, which allowed pleasure craft to pass through the locks as many times as they wished. It was because of the increasing frequency of passages by pleasure craft through the locks that all the lock-keepers made an application in September 1935 to the Lock Staff Special Committee for an uncrease in their wage. The keepers pointed out that launch traffic was increasing and the twelve to fourteen hours they were working each day in the summer months was far in excess of what it used to be. Added to these hours was the increased amount of clerical work that had to be done at the end of a very long day and furthermore, no additional staff had been appointed since the last wage review in 1929.

The keepers were of the opinion that their rates of pay were not in line with the rates received by other men in similar positions in other services, and they trusted that their application would receive the full and generous support of the Conservators. It was their misfortune that the application did not receive the support of the Conservators: this was because the Lock Staff

Special Committee had conveyed to the Conservators that in their opinion no case had been made by the lock-keepers on the grounds of additional work. The Conservators' Finance Committee did, however, review what had happened over the years since 1911 when the Conservators' sub-committee had made the detailed report of the keepers' working conditions. The Finance Committee pointed out that following the report of 1911 the river had been divided into sections on a more or less geographical basis and the wage of each lock-keeper in each section was fixed. While this was an easy way to grade the keepers' wages, it had certain disadvantages because the work at different locks, even in the same geographical section, varied. The workload altered from lock to lock for a number of reasons: the nearness of a lock to a well populated town; the need to regulate a weir adjacent to the lock; the proximity of an incoming tributary or, a working mill. It was evident that even within a fixed geographical area there was a good case for making adjustments to the wage of a keeper whose workload was above the average for the section. The Conservators, however, had always encountered difficulties in their endeavour to reach a completely satisfactory system, and the variation in wage of each keeper so that it was commensurate with the amount of work at the lock, might destroy the usefulness of the existing geographical sections.

Taking these matters into account, the Finance Committee proposed that if the wages at present being paid to the lock-keepers were fair, and if it were desirable to grade the locks, the most equitable method would be to discard the geographical sections of the river and classify the locks on the basis of monetary values. This would ensure that the promotion of a lock-keeper from one grade of lock to another would carry with it an increase in his wage. Such an arrangement, in the opinion of the Finance Committee, would act as an incentive to the keepers to work toward a higher grade of lock and so create a career structure for those who wished to progress in their employment. Hence, the locks were graded into four classes, which brought about an immediate increase in the keepers' pay varying from one shilling a week for a class four lock, to a maximum of two shillings and six pence a week for a class one lock. The new wage structure came into effect on 1 January 1936 and with the new structure, the keepers continued to be supplied with the same amount of working clothing they had been allocated since the nineteen-twenties: each year a jacket, vest, cap and two pairs of trousers, and every three years an overcoat and one pair of water boots.

The lock-keepers' attempt in the autumn of 1935 to bring about what they considered to be a realistic wage settlement had failed, and the subsequent restructuring of the keepers' wages based on the grading of the locks into four classes was in their opinion little more than cosmetic. The

keepers could do nothing more than accept these new conditions and they withdrew from further confrontation with the Conservators until July 1938 when they took the unusual step of sending a deputation to discuss their grievances face-to-face with the Lock Staff Special Committee. The deputation comprised the keeper of Osney, Iffley, Benson, Caversham, Blakes,[1] Sonning and Bray locks and the Lashbrook ferryman. They asked for an increase in their wage of two pounds a week and they would then concede certain privileges that had helped to augment their yearly income.

The chairman of the Lock Staff Special Committee pointed out to the deputation that the income of the Conservators was fixed, and unlike a county council that was able to meet a request for increased wages by increasing the housing rates, the Conservators had no means of increasing their income other than by raising the tolls at each lock. And as this was a step they clearly did not want to take, their income each year varied very little.

In reply to the chairman's opening address the Caversham keeper, who acted as spokesman for the deputation, pointed out that the keepers were on duty twenty-four hours a day, they were responsible for boat traffic, water control, collection of tolls and they were not allowed to leave the lock. The one day a month leave entitlement worked out to be nearer half a day as it was not easy for a keeper to find a reliable person to take charge of the lock, and when they did find a suitable person, it was often after 10 a.m. before the keeper finally handed over his duties. He went on to say that the keepers were on duty absolutely for 345 days each year,[2] while people in other jobs had their evenings free as well as weekends. The keepers also worked on Bank holidays and the annual holiday they took once a year was not available to them until the end of the summer season when the autumn weather was less favourable. The Caversham keeper also pointed out that they seldom were able to get a proper meal during the summer months owing to the increase in pleasure traffic, particularly launches, and they could be called out at night. He next raised the matter of scrubbing the lock sides, pointing out to the Committee that this had to be done between four and five o'clock in the morning to avoid traffic. There were times this could happen when a keeper had been called out in the early hours of the morning prior to the scrubbing, and following the scrubbing he had a full day's work ahead of him. Answering questions put

1. The lock is sited on the river Kennet at Reading and at that time came under the jurisdiction of the Thames Conservancy.
2. It is unclear why the Caversham lock-keeper claimed that the lock staff were on duty 345 days. In October 1929 their existing leave was increased by seven days, which would set the figure at 338 days each year.

to him by the chairman, the Caversham keeper confirmed that all locks had to be scrubbed to remove algae and it was done about four to five times a year. The deputation were of the opinion that this job should be carried out by the engineers' department, which worked only a forty-eight hour week.

The matter of the lock-keepers' so-called privileges was raised, though the chairman appeared unaware what these privileges were. He was aware that the keepers would receive a pension comprising a lump sum and gratuities when they retired; they had a rent free house, certain clothing was supplied and they received coal at a reduced price. In reply to the chairman's uncertainty over this matter, the Sonning keeper explained what the privileges were. He pointed out that when he had become a lock-keeper he was encouraged to carry out other activities when he was not attending the lock, and to this end he built some sheds and carried out work on private boats. The Bray keeper had a boat-house at his lock and he rented it out for winter storage. Certain lock-keeper's wives provided refreshments and teas at the lock. But inexplicably these privileges had been withdrawn about twelve months earlier. The Caversham keeper stated that the money collected by the keepers from these activities provided about fifty shillings a year, which some keepers used as holiday money.

To conclude the meeting, the Caversham keeper proposed that wages at the locks should be levelled. He pointed out that 'all' the keepers had served in the Army or Navy and the pensions they received had to be used to supplement their conservancy wage, and hence, their service pension could not be saved until they retired.

Almost three months later the Lock Staff Special Committee made their recommendations to the Conservators. First, they gave a brief review of previous claims by the lock-keepers: in 1911 the keepers had asked for a wage increase that was partly granted and at the same time a geographical classification of the locks was adopted. The keepers' wages were adjusted in 1920 and 1927, and in 1929 their wages were reviewed and the cost of living bonus abolished. In 1936, upon a further application by the lock staff, a new non-geographical classification of the locks was adopted comprising four classes. Now, in 1938, a further application had been made by the lock staff, which at that time comprised forty-four lock-keepers, nine assistants and nine ferrymen.

The Committee reported that the additional two pounds a week the lock staff requested was 'neither justifiable nor practicable', and they considered the 168 hours a week the lock staff claimed they were required to work an exageration. And in any case, there was an 'appreciable measure of relief from actual work' in their opinion. But the Committee did feel that some increase in lock staff wages was justifiable owing to the increase in the

number of launches using the river.

Regarding the number of hours the lock staff were required to work each day, the Committee conceded that the twenty-four hours a day they had to be on duty was no longer realistic, except for the keepers and assistants at Molesey and Teddington locks, which regularly passed barges during the night. Therefore, they recommended that lock and ferry staff should have their working hours limited from 7 a.m. to 11 p.m. during summer and from 7 a.m. to 6 p.m. for the other months of the year. Outside these hours they recommended the locks and ferrys should be closed.

The request by the lock staff that their annual leave should be increased from two to three weeks did not meet with the Committee's approval, but the Committee did propose that the lock staff have a clear twenty-four hour period of leave once a week including a Sunday by rotation. In order to implement this arrangement the Committee proposed setting up a new class of Relief Lock-Keeper who would be available to deputise for the permanent keepers and would receive a lodging allowance and be provided with a bicycle and a uniform.

The matter of scrubbing the lock sides and the request by the lock staff that it should be done by the engineers' department, was rejected by the Committee. 'It was', they reported, 'the responsibility of the keeper, as part of his job conditions to keep the lock, weir, house, garden and premises in a proper and orderly condition, and the lock sides and steps clean.'

The lock staff had made a set of proposals they considered fair and reasonable, but again their requests were not met in full and in the matter of their request for an additional two pounds a week, they had to make do with an extra four shillings a week for keepers and two shillings a week for regular assistants.

Further moves by the lock staff in connection with their pay and working conditions were thwarted by the onset of war in the autumn of 1939. Within a year, many of the eligible lock and ferry staff had left for war service, leaving the locks in the hands of their wives and the older members of the lock staff; a situation that had also occured during the First World War. Not unexpectedly, the pattern of traffic on the river changed during the period from 1940 to 1945; the number of small craft privately owned and available for hire declined in the first year of the war, and by 1942 the number of registered launches on the river had declined by more than half the number using the river in the nineteen-thirties. But the volume of merchandise conveyed on the river following an initial drop in 1940 began to increase dramatically and reached a peak in 1944, falling back in 1946 to a level lower than the pre-war level and not re-establishing the earlier level

until 1949. There would seem little doubt that the hours worked by the lock staff during the war years had not been lightened.

The war brought about another change in the activities of the lock-keepers and that was the cessation of awarding the Sir Reginald Hanson Challenge Cup for the best lock garden on the river, although in 1940 the Sonning lock-keeper's garden was of such high quality that he received two guineas. Instead of receiving seeds for flowers each year, the lock staff were provided with seeds for growing vegetables and the practice was not reversed until 1949, even though the Hanson cup was re-introduced a year earlier.

In the immediate post-war years the lock staff formed the Lock-Keepers' Welfare Committee and one of their first actions in January 1947 was to request improvements in pay and working conditions. The keepers were most concerned about the provision of electricity for their houses as many were lighted by paraffin oil lamps and oil was still rationed. They asked for new overalls every three years to protect them for dirty work and scrubbing the sides of the locks, and in addition they requested a further seven coupons from the Board of Trade for footware. And with regard to their leave entitlement, they wanted a day's leave in lieu of a Bank holiday or, alternatively, a day's pay.

The Lock Staff Special Committee conceded their requests though the matter of the extra coupons was discouraged as the keepers were included in the civilian uniform concession, which was already on the generous side. New rates of pay were proposed based on a re-classification of the existing four grades of keeper, to five grades, and the re-classification of the locks on the basis of importance and amount of work done.

Although fuel for pleasure craft using the river was restricted in the immediate post-war years, the rapid increase in the number of launches on the river continued and by 1948 the Conservators had begun to receive complaints regarding the closure of the locks outwith the keepers' normal hours of duty as defined in the agreement of 1938. The complainants raised the matter of the right of the public to navigate the river at all hours. But the stumbling block they came upon was bye-law 48 of the Conservators' Navigation and General Bye-Laws, 1934, which stated: 'No person shall without the previous express request or consent of the Lock-keeper first obtained use interfere or meddle with the gear at any lock or weir or with any sluice belonging to the Conservators.' However, the Conservators did not fail to see that a compromise was necessary and they agreed that outside the normal hours worked by the lock-keepers the public could operate the locks and ferries, though entirely at their own risk and responsibility.

The post-war years also saw a pattern of change in the way the locks were used. Although there was a brief fall in the volume of merchandise conveyed through the locks during the late nineteen-forties, it quickly re-established itself reaching a peak in 1951 and then falling steadily until 1972 when the volume had become barely one per cent of earlier years. At the same time, pleasure craft registered on the river were increasing rapidly and by 1972 the number had doubled since the earlier years. The number of small craft privately owned was also increasing while the number of craft let or plying for hire was decreasing. It was, therefore, the period 1952 to 1972 that showed the most pronounced pattern of change on the river, resulting in the lock-keepers' future as conveyers of pleasure traffic. As this began to take effect the Conservators introduced a draft proposal dealing with instructions to lock and ferry staff. Their previously printed instructions had been released in 1933 and now, twenty years later, they generated a comprehensive document dealing with all aspects of the duties to be performed by the lock and ferry staff.

The lock and ferry staff were to work under the orders of their district inspector and the chief navigation officer. The new instructions required them to treat the public, who were quickly becoming the principal users of the locks, with courtesy and civility. It is not surprising that the Conservators added this instruction as they had received from time to time complaints from river users of the surly behaviour of certain lock-keepers. The management of the lock, weir or ferry was the first duty of the lock and ferry staff and they were required not to neglect their duty in pursuance of work of a private nature. Furthermore, they would not be allowed to accept a reward or bribe in return for undue preference in passing a boat through a lock and if they did so, a fine of twenty pounds would be incurred. While on duty the keepers and ferrymen were required to wear their full uniform, and during the summer months white cap covers must be worn. They were also required not to wear brown boots or shoes and coloured ties with their uniform.

The Conservators made it clear in their instructions that the lock, weir, lock-house or ferry-house, the premises and gardens, were to be kept in proper and orderly condition. And at the same time the lock sides and steps kept clean, as well as maintaining ferry dinghies and punts in a clean and efficient condition. The lock-keepers would need to ensure that the lifting gear on the weir and lock gate sluices was oiled and kept in a clean condition and any faults reported to the district inspector.

With regard to the regulation of traffic through the locks, the keepers' prime duty was to ensure the safety and convenience of the public; they were not to delay unnecessarily or obstruct any vessel or person.

Nevertheless, they must give a barge precedence over a pleasure craft when both approached the lock at the same time; and a launch arriving at a lock at the same time as a pleasure boat should enter and leave the lock ahead of the other boat. The Conservators were aware of a tendency among the lock-keepers to open only one gate if they could see that a vessel would pass through the narrower opening. Hence, the keepers were instructed that both gates must be opened irrespective of the size of the approaching vessel if the navigator requested them to do so.

Instructions concerning the lock-keepers' need to regulate the weirs associated with the locks were much more specific in the Conservators' new document, and the keepers were left in no doubt that adjusting the weir to maintain the level of head water as nearly as possible to the head water mark indicated at the lock must be carried out at any time of day or night. The keepers were also required to maintain a record of the head and tail water levels at the lock and report any unexplained fluctuations to the district inspector.

Among the miscellaneous instructions the Conservators prepared were certain clauses to avoid earlier misunderstandings regarding work carried out privately by keepers. A keeper or ferryman who had boats for hire could keep no more than three, and this was subject to there being no boat hire business within a quarter of a mile of the lock. If such a business existed, the keeper or ferryman was restricted to one boat. Storing, repairing and re-varnishing boats not belonging to the lock staff was not permitted. Keepers would furthermore not be allowed to sell fermented liquors or home-made wines or dewlock. And finally, the instructions reminded the keepers and ferrymen that their duties were from 9 a.m. until sunset, though outside those hours adjustments to weirs still had to be made. In the winter months it was the duty of the lock-keepers to ensure that ice forming in the lock-cut was broken up and passed through the lock, and ice forming in front of the weir was also broken up.

The Conservators' instructions to its lock staff in 1953 have remained more or less in the same form to the present time. Since 1957 a programme of work involving the reconstruction and modernisation of some of the lock-houses and ferry cottages, as well as the modernisation of many of the locks, appreciably raised the quality of lock-keeping as a profession. And concurrent with the programme of work, the Conservators examined the pay structure for their lock staff. The way they went about it was to engage a team of 'work study' consultants who visited each lock over a period of a number of years. They decided to allocate points to each lock based on the work-load of the lock-keeper, with the amount of traffic passing through the

lock a major factor in determining the number of points; but other matters were taken into account as well, such as the distance the keeper had to walk to the weir and the size of the weir, the area of lock garden to be maintained and other tasks the keeper was required to undertake.

With advances in engineering in the nineteen-sixties it became inevitable that some of the lock-keepers' work would be taken over or supplemented by advanced forms of instrumentation and control. A major change to the locks below Oxford, which carried the main burden of river traffic, involved a change in the way the gates and sluices were moved, so that the keeper had only to operate an hydraulic system to empty or fill the lock and open and close the gates, where before this had been a manual operation.

Even though the keepers are required to keep a note of water levels at their locks and weirs in the form of handwritten records, there was clearly a need to note this information automatically as a back-up to the keepers' own records. Certain weirs on the river were designated gauging stations because of their proximity to sites where water is abstracted from the river for industrial purposes, or in instances where certain geological conditions exist. At these stations water level recorders are installed in the form of a chart recorder that indicates water level against time. With this information the hydrology section of the present administration is able to calculate the daily average flow of water through the weir. Although the information recorded is normally not used by the lock-keeper, he is required to change the charts on a weekly basis and forward the recorded data to the hydrology section for analysis.

In addition to the recorders at the gauging stations, every lock is fitted with water level sensors that measure water levels at the head and tail of the lock. The sensors return electrical signals to an instrument known as a 'trend monitor' which is situated in the lock-keeper's hut at the side of the lock. The monitor enables the lock-keeper to see in graphical form on a solid-state display how the water levels have changed over a twenty-four hour period. Should there be marked changes in water levels at night owing to heavy rain or a malfunction of the weir, alarm bands on the display trigger a warning device in the lock-keeper's house. The same water level sensors at certain key sites are used to convey water level information by way of a telemetry link to a computer system (Argus) at the river control room at Reading in Berkshire. This information together with the charts from the gauging stations enable the river control room to assess conditions on a day to day basis in the different regions of the river, which is essential to the overall management of the river. Even though the information transmitted to the river control room is automatic, there is still a person to person link between the lock-keepers and the river control room through

their district navigation officer. This remains an essential feature of the management of the river as in certain conditions it is the personal observations of the lock-keepers that will be the decisive factor in a decision made by the control room. There is no doubt, however, that irrespective of past and future technological developments, the presence of a keeper at each lock is essential to the proper functioning of the lock and the safety of river traffic.

4

LOCK CONSTRUCTION IN THE 17th, 18th AND 19th CENTURIES

References to lock construction in europe can be traced back to 1452 when the Italian architect Leo Battista Alberti discussed a method for constructing a lock. Three centuries later his notes were translated by James Leoni and from the translation it is possible to visualise how a lock may have been built in mid-fifteenth century Italy. Alberti stated that two types of lock were possible and he described one lock operated by sluices (*cataractis*) and another by floodgates (*valvis*). He pointed out that both types of lock required that the 'sides must be made full as strong as the piers of a bridge.' The former type of lock required that the heaviest sluice could be drawn up without danger and to achieve this he proposed that 'applying to the spindle a windlass (*tractorum fusume*), which is to draw up the sluice wheels notch'd with teeth like the wheels of a clock, which must take hold of the teeth of the other spindle, which is to be put in motion by them. But the most convenient of all', Alberti claimed, 'is the floodgate (*valva*), which in the middle has a spindle, that turns upon a perpendicular axis; to this spindle is fastened a broad square valve, like the square sail of a barge, which may be easily turned about to which side of the vessel the master pleases; but the two sides of this valve shall not be exactly equal to one another in breadth, but let one be about three inches narrower than the other; by which means it may be opened by a child, and will shut again by itself, because the weight of the broader side will exceed that of the narrower.' The methods described by Alberti were, however, quite different from the method proposed by Leonardo da Vinci in about 1495. He conceived the idea of mitre gates for the lock at San Marco situated below the terminal basin of the Martesana canal in Milan, a brilliant innovation that has dominated lock design to the present day. In England, the first locks were built in 1564-67 on the Exeter canal and mitre gates were

employed at the head of each lock and a single gate at the tail. The first locks on the Thames were direct descendants of those on the Exeter canal, though they used a pair of mitre gates at the head and the tail of the lock chamber.

The principal function of the lock is to move river traffic in a safe and efficient way. The size of the lock is determined by the style and size of vessel it is required to handle; the number of vessels that are likely to pass through the lock; the required filling and emptying time and the approach conditions to the lock. The early locks on the Thames were designed to handle commercial traffic mainly in the form of barges, and the size of barge commonly in use on a section of the river would determine the length and breadth of the lock chamber. Owing to the increase in tonnage of barges during the eighteenth and early nineteenth century it was not uncommon for locks to be rebuilt so that larger vessels could be accommodated. Beside the length and breadth of the lock chamber is the depth of the lock, as it is essential in the case of a barge taking up the entire space of the lock chamber that sufficient water should be below the vessel. In addition, the placing of the head and tail sills is another factor in lock design. The tail sill should be at the level of the floor of the lock chamber and preferably higher than the bed of the river immediately below the lock. This arrangement provides an extra degree of manouverability and safety from grounding as the vessel passes out of the lock. The placing of the head sill is a compromise between reducing the size of the head gates and ensuring that seasonal low levels of the river still provide sufficient water in the lock to cover the sluices in the head gates. In this way the sluices are discharging below the level of water in the lock at the very beginning of the filling period. The filling and emptying time of the lock should ideally be about four to six minutes, though in practice the filling time can be longer owing to the need to reduce turbulence caused when the sluices in the head gates are opened. When a barge or other large vessel fills the lock chamber entirely, the turbulence is of less concern than in an instance when the lock contains a number of small craft that might easily be swamped, and it is in these situations that the lock-keeper's knowledge of his lock determines how quickly he allows the lock chamber to fill. The emptying time may also need some degree of control when small craft waiting below the tail gates to enter the lock could be at risk by a rapid discharge through the sluices in the gates. A further factor concerning lock design is the approach conditions at the head of the lock. The approach to the lock may be close to a weir and in this case it is essential that sufficient room is allowed between the weir and the lay-by where craft temporarily moor while waiting to enter the lock. Hence the siting of the entrance to

the lock should offer adequate space to allow safe passage in and out of the lock and provide sufficient manoeuvreability for vessels in times when there is a strong stream running.

The style of construction of one of the three locks built by the Oxford Commissioners in the sixteen-thirties is indicated by Thacker who in 1910 visited the site of the then disused lock in the Swift Ditch: 'Its gates are all gone; and except for the growth there is a clear passage into it. Its basin is perhaps under twenty feet in width, and seventy-five to eighty feet in length; approximating to the original length of Sandford and Iffley. There is no exit; the lower gates were removed a century ago and replaced with a solid dam of masonry. The walls are of firm and exact stonework, beautifully laid; much superior to a good deal of later construction.' From Thacker's description there is little doubt that the lock used two gates at the head and two at the tail, though the construction of the sluice in each gate is open to speculation. It is probable that what Thacker saw almost 280 years after the construction of the lock was the original stonework, because in addition he commented that 'these original locks [Iffley, Sandford, Swift Ditch] were of solid and beautifully joined masonry'.

This beginning in terms of the solidity of construction of the early locks did not continue during the early administration of the Thames Navigation Commissioners, whose first series of locks built in 1772/73 were of timber. A number of these locks were of open-sided construction and an example was Hambleden lock, built in January 1773. The navigable width of the lock was set at the head and tail by opposing rows of oak piles that supported the head and tail gates; in between the two sets of gates the earth was dug out to create a roughly shaped oval chamber. The chamber itself had its navigable width determined by a series of oak piles supported by longitudinal beams running the length of the chamber and in line with the piles supporting the gates. It was not uncommon that on one side of the chamber there would be a gap between the piles, and in some instances the piles were extended back towards the bank forming a lay-by, possibly to allow bargemen access to the lock side.

Not all the locks built in 1773 were open-sided; Marlow and Marsh had closed sides with boarding lining the land side of the timber piles so defining the volume of the chamber and reducing the amount of water needed to fill the lock. The timber selected for construction was mainly oak, although Hurley, Marsh, Shiplake and Sonning were constructed with fir. But this was not such a durable timber and the latter three locks were rebuilt with oak. In the case of Hurley lock, the timber construction was found to be unsatisfactory for the chosen siting of the lock, and instead of replacing the fir entirely with oak, a brick construction was adopted, and

three years later the abutments were replaced with stone.

Because of the difficulties encountered with Hurley lock, the Commissioners engaged William Jessop in 1786 to advise them on the construction of the second series of locks they intended to build from Day's to Whitchurch. Jessop provided estimates for three forms of construction: an all timber lock using oak and elm, a brick construction, and a stone construction with brick backing. The lowest estimate of cost was the all-timber lock; the brick construction was ten per cent more than the all-timber lock and the stone and brick construction thirty-eight per cent more. Jessop indicated in his report to the Commissioners that the brick construction was in every respect as good as the stone and brick construction, though he gave no reason why this should be the case.

At the time of Jessop's report, Mapledurham and Caversham locks had already been built in 1778 using fir, while the locks from Day's to Whitchurch (1787-89) were built with oak, which was the least expensive option proposed by Jessop.

In his first of two reports to the Thames Navigation Commissioners in 1789 when the first and second series of locks had been built, William Jessop commented that in his opinion a lock chamber with walls was not absolutely necessary, though they did preserve the lock chamber as a fixed volume. He acknowledged that a lock chamber with open sides would suffer from erosion; in addition, the extra space between the piling and the bank on each side would mean a larger volume of water to fill the lock, and this in turn would bring about longer filling and emptying times. A further comment he made concerned the sluices in the lock gates; he felt that they were often too small and in his opinion a sluice should never be less than two square feet.

The third series of locks built above Oxford by the Thames Commissioners in 1790 was entirely of stone. It is interesting to note that the Commissioners having decided upon the least expensive form of construction for their first and second series of locks, chose the most expensive form of construction for the third series. Even though the locks above Oxford were smaller than those below the city, it is difficult to concede that the cost differential between timber and stone was significantly less than the estimates prepared by Jessop three years earlier, though he had indicated that a cheap source of stone was available by way of the Thames and Severn canal.

Molesey lock, one of the fourth series of locks and built by the City of London Corporation is an example of a lock constructed entirely of timber. Molesey lock at the time it was built in 1815 was much larger than the locks

above Staines: it was 154 feet in length and twenty-two feet in width. The entire floor of the lock was constructed of timber and comprised three equi-spaced rows of piles running the length of the lock; the piles were driven into the ground at intervals of six feet and each group of three piles supported a beam running from side to side of the lock chamber. This arrangement of transverse beams provided the base for securing the longitudinal planking which formed the floor of the lock chamber. Each wall of the chamber comprised a row of piles driven vertically into the ground and every pile was in line with a transverse beam in the base of the floor. The piles were supported in their vertical position by two beams that ran the length of the chamber; one beam was midway between the floor of the chamber and the top of the chamber, while the second beam was almost at the top of the chamber. In this way the chamber of the lock presented a flat planked floor and walls formed of vertical piles and horizontal beams. The walls were sealed on the land side by vertical planking, though such a structure alone would not support itself owing to the pressure of soil and groundwater on the land side of each wall. To hold the vertical piles of the walls in position, a further row of piles was driven into the ground fourteen feet from each wall, with each pile in line with the corresponding vertical pile of the wall. The piles were joined with land-ties formed of beams of timber, and in certain positions the land-tie would be extended a further ten feet to an additional securing pile. This arrangement formed the lock chamber, but beyond each end of the chamber, where the head gates and tail gates were placed, the arrangement of piling and planking continued for a further thirty feet. This meant that the upstream bed of the river as it approached the head of the lock would continue as a boarded floor to a sill formed of a massive beam set across the width of the lock before the head gates. Where the head gates moved from the open to the closed position, the boarded floor was at a level below the sill, while the floor of the lock chamber was set at a slightly lower level. The lower sill was situated before the tail gates and again the floor dropped to coincide with the bed of the river downstream. At the time Molesey lock was built, the fall between the upper and lower sill was about two feet.

The head and tail gates of the lock were of timber and in the form of a frame comprising vertical and horizontal beams with diagonal planking on one side of each gate. Each sluice (one to each gate) was in the form of a rectangular shaped opening of about four by two feet, and a wooden paddle acting as a shutter was raised or lowered by a lever at the top of each gate, the lever being of sufficient length to enable the lock-keeper to draw the paddle against the pressure of water. Similarly, each gate was fitted with a balance-beam to provide the necessary leverage that would

allow the keeper to open the gate without assistance. The timber selected for the construction of the lock is not specified on the plan, but it is probable that oak was used with elm for those parts permanently under water.

The locks during the seventeenth, eighteenth and the first half of the nineteenth century were primarily to pass commercial traffic in the form of barges, but by the eighteen-fifties pleasure traffic had begun to increase and at times the function of the lock was to pass a number of small craft as opposed to say, a single barge. Boat rollers were therefore introduced at a number of locks to handle the large number of canoes, punts and skiffs using the river at week-ends and public holidays. This provided the users of small boats with a means of by-passing the lock by manhandling their craft over a set of rollers between the level of the river at the head and tail of the lock; the rollers usually running parallel to and at a distance from one side of the lock.

No doubt it had occurred to the Conservators of the River Thames that lock design would need to change to accommodate the changing style of river traffic, and when the Thames Act of 1883 gave the Conservators the necessary powers to register all pleasure craft using the river, they were probably aware that the locks as a means of passing only commercial traffic was a thing of the past. Nevertheless, no immediate design changes to the locks took place and it was not until the early part of the twentieth century that advances in civil engineering determined the way in which locks would be built in the future.

LOCK CONSTRUCTION IN THE EARLY 20th CENTURY

Since the time that William Jessop recommended a sluice of not less than two square feet in each lock gate, major changes to the filling and emptying system on some of the Thames locks has taken place; but these changes are recent and they will be discussed later. The sluices used on most of the Thames locks are very much the same arrangement as in Jessop's time. The changes that have taken place are the various ways in which the sluices are operated. In effect, the sluice is simply an aperture in the lock gate below water level that can be opened and closed with a form of shutter. The operation of sluices became easier when a counterbalance arrangement was adopted in preference to a simple rack and pinion. With the rack and pinion, considerable force was needed to wind the rack up and with it the

shutter, whereas a counterbalance weight and a wheel and gear arrangement enables the operator to raise and lower the shutter by applying very little force. This latter arrangement has been used since the early part of this century and is still in use today on the locks from St John's at Lechlade to King's at Oxford. In the nineteen-sixties, the locks from Godstow to Teddington were converted so that manual operation of the gates and sluices was no longer needed and following some initial trials using electric motors, hydraulic power was adopted.

The construction of traditional lock gates, often referred to as mitre gates, has not changed greatly since the early seventeenth century. Mitre gates provide the most straightforward way of letting boats in and out of a lock. The gates are made of hardwood in the form of a frame with oak the most commonly used timber, though in more recent times, hardwoods such as greenheart and ekki have been used. The frame is usually faced with softwood planking so that should there be a need, it can easily be replaced during the life of the frame. The heel post of the frame is the pivot of the frame about which the gate turns. At the bottom of the heel post is fitted an offset cast-iron shoe which sits in a pintle secured to the floor of the lock. At the top of the heel post is a loose fitting collar-strap which holds the gate in position, but allows it to swing freely when it is not under pressure of water. When the gate is under pressure, that is, the gate is closed, the heel post of each gate is forced into the hollowed quoin of the lock wall, thus providing an effective seal. Once the water inside and outside the lock is level, the gates are no longer under pressure and they move freely. The traditional method of moving a lock gate to the open or closed position is a beam of wood attached to the top of the frame of the gate and projecting beyond the gate to form what is in effect a simple lever. The beam is usually referred to as a balance beam and its moment is about the heel post. Applying basic mechanics, the length of the beam is selected so that the force exerted at its end by a man of average strength is sufficient to move the mass of the gate in water.

In 1923 the Thames Conservancy called an engineering conference to establish new designs for locks, weirs and a mechanical boat conveyor. The proposed boat conveyor, which would take the place of boat rollers at certain locks, would be driven by a motor and comprise two conveyor platforms moved by chain-belts, with each platform divided by a footway and an additional footway on the outside of each conveyor platform; weirs would be constructed of pre-cast concrete with permanent steel piling and concrete blocks underwater to avoid erosion; locks would comprise steel piling along each side of the lock chamber and joined to anchor blocks by

tie rods. The chamber of the lock would be lined in concrete with timber rubbing piles set in the concrete walls, in this way vessels would be protected when entering and leaving the lock.

The design proposals that came out of the 1923 engineering conference were applied to the reconstruction of Godstow lock in 1924. The new lock was constructed of concrete and steel piling and the frames of the gates were of greenheart. Three years later new locks were constructed at King's and Eynsham, but in both instances they were built of mass concrete, and the frames of the gates again were of greenheart. The different methods of construction of the locks at Godstow, King's and Eynsham came about because Godstow was an existing lock and the intention was to widen and deepen the chamber. The original width was fourteen feet two inches and to widen it to seventeen feet, steel piling was driven in each side of the existing chamber and the remains of the old chamber excavated. The piling was secured by land ties and the newly formed steel chamber lined with concrete. But King's and Eynsham locks were constructed at new sites and in these circumstances there was no existing lock to reconstruct. As the land could be worked first and the cuts leading into the head and tail of each lock carried out later, the new sites were excavated and the walls of each chamber built of mass concrete with the lower part of the walls of King's three feet eight inches thick and graduated in two steps to a final width of two feet six inches at the top. In this way the lower part of the walls are able to resist the loading caused by the pressure of soil and groundwater on the outside of the chamber. The thickness of the walls of Eynsham lock are almost identical.

Following the reconstruction of Godstow lock, other locks were enlarged and reconstructed in one operation. The method using steel piling to create a coffer-dam was found to be a particularly attractive way of reconstructing an existing lock. Once the steel piling is in position, the old lock chamber is excavated and the removal of the old gates is done within the coffer-dam, which extends beyond the gates at each end of the lock. Finally, the steel piling defining the position of the walls of the lock chamber becomes part of the permanent structure of the new lock, while the piling outside the head and tail gates is removed when the new gates have been installed.

LOCK CONSTRUCTION IN THE LATE 20th CENTURY

During the nineteen-forties a change in the way the river was used began to

take place. Commercial traffic, which had attained an all-time peak during 1943 and 1944, began to decline, and except for a brief surge in the early nineteen-fifties, it never recovered and dwindled to almost next to nothing by 1972. At the same time the number of pleasure vessels using the river from 1945 showed a slow but gradual increase. By the nineteen-sixties or even earlier the Thames Conservancy saw that the future of the river was as a waterway exclusively for pleasure traffic. They also realised that this would mean handling increasing numbers of small vessels through the locks and only rarely barge traffic. Among the many factors concerning navigation on the river, the quick and efficient passage of a large number of small vessels through the locks was the important factor that influenced lock design. The introduction of hydraulic control of lock gates and sluices in the nineteen-sixties had already cut down the time for passing a number of vessels through a lock, and if a filling system of advanced design could be made to fill the lock chamber more quickly with a minimum amount of turbulence, then the locking time would be reduced further.

Taking these matters into account, the Thames Conservancy introduced an entirely new filling system with the reconstruction of Sandford lock in 1972/73. The reconstruction process followed the now established pattern of enclosing the old lock within a coffer-dam, in this instance comprising 424 steel piles restrained by seventy-eight drilled ground anchors, and then excavating the interior. The new floor of the lock chamber was constructed of reinforced concrete and below the floor two thirty inch diameter culverts run along each side of the chamber with each culvert breaking out into thirteen outlets spaced at equal intervals in the floor. Two intake chambers, one outside each head gate of the lock, let water into the culverts which in turn distribute the water down the length of the chamber and through the outlets in the floor. The system eliminated the need for sluices in the head gates, though sluices are retained in the tail gates so that the emptying process remained the same as in previously constructed locks. The steel piling is faced with reinforced concrete to an average thickness of fifteen inches and the areas about the gates are formed of mass concrete; the gates are built from greenheart. Hydraulic controls operate the sluices governing the water entering the intake chambers as well as the operation of the sluices in the tail gates. Similarly, hydraulic controls open and close the lock gates which no longer require balance beams.

The reconstruction of Sandford lock using an underfloor filling system had been adopted because of the difference in water levels at the head and tail of the lock,[1] which at times meant that the sluices in the head gates

1. Sandford lock is the deepest lock on the upper river with a fall of 8 ft 10 in.

were partly above tail water level. While the underfloor system eliminated this problem and at the same time reduced turbulence in the region of the head gates when the lock was filling, it also contributed greatly to the efficiency of the filling process of the lock chamber.

The work carried out during the period of reconstruction of Sandford lock occupied the civil engineering contractors for six months, and during that time they built a temporary bridge across the lock-cut and a temporary road for the movement of plant and materials. Because of the proximity of buildings adjacent to the lock, some of the steel piles were driven in using a vibration-free pile driver.

The underfloor filling system used in the reconstruction of Sandford lock was not without its faults when the design was put into practice. The principal area of concern was the way water entered the lock chamber by way of the two culverts and twenty-six outlets. During the filling process the outlets create an uneven distribution of water entering the lock chamber as the pressure of water lessens as it passes down each culvert. In addition, the time taken to fill the lock chamber is increased by the way water is taken into the system. The intakes, which incorporate the sluices, are set in the concrete abutments forming the entrance to the head of the lock and water passes from the intakes into two vertical drains leading to the culverts. Each intake is set just below head water level in a position where the pressure of water is not as high as it would be if the intakes were set at a lower level. Hence, water is driven into the culverts at a pressure determined by the volume of water in each of the vertical drains. Although the filling time of the new lock is about the same as the old lock, the new lock had been lengthened and widened during reconstruction resulting in a chamber of almost twice the volume of the old lock, and hence double the volume of water. As the filling times are about the same, a much faster intake of water is indicated, though the intake diminishes owing to the back pressure created as the lock chamber fills. Initially the chamber fills very quickly, but the final stage of raising the water level the last foot or so takes as long as the first part of the cycle.

No doubt it was evident to the Thames Conservancy that these were important factors in the design of Sandford lock that needed to be revised for the next lock reconstruction programme, which was undertaken at Bell Weir during the winter of 1973/74. As with Sandford lock, the traditional sluices in the tail gates are retained, but the underfloor filling system is a revised arrangement using four underfloor culverts equally spaced and offering a more even distribution of the outlets in the floor of the lock chamber. The pressure that water is forced into the culverts is increased by positioning the intakes to the culverts in the head sill, which is situated

directly behind the head gates. When the head gates are closed, the lower part of each gate covers the intakes and the control of water is carried out by four conventional sluices, two in each gate with each sluice covering the intake to each culvert. In this way the filling time of the reconstructed Bell Weir lock is greatly enhanced owing to the increase in water pressure to the culverts, as well as the increased number of outlets in the floor of the lock chamber.

Six years elapsed before the major reconstruction of another existing lock took place. In this instance it was Romney lock that was enlarged and reconstructed during the winter of 1979/80 on the same lines as Bell Weir lock. The one design change was the arrangement of the underfloor culverts and their outlets. This was necessary as the arrangement used for Bell Weir lock still lacked an even distribution of water down the length of the lock chamber owing to the falling pressure of water as it passes down each culvert. The problem is partly resolved in the revised layout of the outlets from the culverts. Of the four culverts, the two outer culverts present nine outlets each, but only in the first half of the lock floor, while the two inner culverts present the same number of outlets in the second half of the floor. By using this arrangement the filling action of the upper and lower part of the lock chamber is more balanced as the pressure of water in each pair of culverts is the same.

At the time of completion of Romney lock it would appear that lock design had reached a stage that could be considered satisfactory for future reconstruction programmes of other Thames locks. Romney and Bell Weir locks are identical in construction, save for the re-arrangement of the underfloor culverts and outlets for Romney lock. Traditional sluices are retained in the upper and lower gates except that in the upper gates the sluices empty directly into the underfloor culverts. Turbulence has been reduced to a minimum while fast filling times are achieved owing to the positioning of the intakes to the culverts in the head sill of the lock. However, when plans were prepared in 1991 for the next major lock reconstruction programme at Hambleden during the winter of 1993/94, they differed very much from the design of Romney and Bell Weir, the major difference being the introduction of independent sluices for filling and emptying the lock chamber. This new arrangement comprises two inlets situated before the head gates and two outlets after the tail gates, both set well below head and tail water levels. At the head of the lock each inlet comprises two penstocks and sluices situated in the concrete walls that form the entrance to the lock, with an identical arrangement at the tail of the lock. Each pair of penstocks is linked by ducting under the head and tail

gates to the underfloor culverts, of which there are four, and the culverts present a total of thirty-six outlets (nine to each culvert) in the form of short ducts angled toward the walls of the lock chamber. As each pair of penstocks perform an identical function, the filling and emptying process is the same action. Opening the sluices in the head penstocks allows water to enter the chamber through the thirty-six outlets in the floor, while opening the sluices in the tail penstocks simply reverses the process; that is, the outlets act as inlets and water passes back into the culverts and out through the tail penstocks. This arrangement brings with it an additional simplification to the overall design of the lock, and that is the construction of the lock gates is unimpeded by the more traditional sluices. In this instance the gates are an all steel construction and are the first working gates to be used on a Thames lock that are not made of wood. Unlike the locks using the underfloor filling system that preceded Hambleden lock, the work programme required that construction was done during two consecutive winters. The piling for the coffer-dam surrounding the old lock was completed in a period of ten weeks with the steel piles left exposed about three feet above ground level. In this way the old lock could continue to be used from Easter 1993 until the end of September. The next stage involved the demolition of the old lock by excavating within the coffer-dam and then proceeding with the construction of the new concrete chamber. The concrete used for the construction of the lock was a water-retaining blend of ordinary cement and ground granulated blast-furnace slag, while the durability of the walls of the chamber has been improved by controlling the permeability of the concrete by stretching a porous material over the temporary wooden shutters used in the construction.

Although Hambleden lock is the most advanced design of any lock on the river, not only providing ease of maintenance but reducing manufacturing costs by using identical penstocks for the inlet and outlet chambers, and steel gates of simple construction unhindered by sluices, it is in doubt whether this design in its present form will be used for future lock reconstruction. This may be partly to do with a recent decision to replace the wooden gates at Sandford lock with steel gates of the same pattern as the Hambleden lock gates, but with conventional sluices in the head gates to supplement the final stage of the filling cycle. Hence, it is likely that the reconstruction of locks in the future will comprise an underfloor ducted system with sluices in the head gates to improve the final stage of filling. Mitre gates will be of rolled steel channel construction protected by rubbing timbers, and wooden seals between the gates and quoins.

It may appear a retrograde step in lock reconstruction that the symmetry of Hambleden lock in terms of the filling and emptying process is not to be

persued by the present administration. But today the reconstruction of a Thames lock is an expensive undertaking and since the reconstruction of Sandford lock, and twenty-one years later the reconstruction of Hambleden lock, much valuable knowledge has been gained so that it is now possible to see more clearly how further locks should be designed with the future needs of the river together with economy of construction in mind.

5

THE 20th CENTURY AND BEYOND

Looking back to the seventeenth century when the first locks were built, the traffic on the river was for the conveyancing of merchandise and improvements to navigation were for one purpose only, to bring about the more efficient movement of this traffic. In the eighteenth century the need to transport goods by water increased and canals were cut. Almost at the end of the century two of these canals, the Thames and Severn and the Oxford, were joined with the Thames in the belief that the river would ensure the swift passage of goods from places along these waterways to London. But this did not come about in the way the canal companies had hoped and some of the reasons have already been outlined. The nineteenth century brought about the seeds of change in the way the river was used, even though until the middle of the century river traffic remained predominantly commercial. With the advent of the railways and the branch lines that joined with the riverside towns, they brought with them passengers whose principal interest was to take pleasure in the river. In this way the beginnings of pleasure traffic on the river came about and by the latter part of the century the river shared a declining commercial trade with an increasing number of pleasure craft. So much so that by 1887 tolls taken at the locks from pleasure traffic were about three times the amount taken from commercial traffic; what the railways were taking away in terms of revenue from commercial traffic, they were effectively replacing with revenue from pleasure traffic.

Although the change in the way the river was being used came about in the latter half of the nineteenth century, it is the twentieth century that has seen the most dramatic changes. Until the outbreak of the Second World War in 1939, commercial traffic had remained at an uneasy level averaging about 320,000 tons a year. Over the same period the number of pleasure

vessels registered on the river showed a slight but noticeable decline. This came about because the number of small craft privately owned began to decrease, though small craft let or plying for hire remained fairly stable; launches gradually increased in number and houseboats decreased. During the period of the Second World War the expected decline in pleasure traffic took place, but at the same time the quantity of merchandise conveyed on the river increased, reaching about 600,000 tons in 1943 and 1944. With the end of the war a new pattern of transport on the river took shape; registered pleasure vessels increased so that by the end of the administration of the Thames Conservancy in 1974 there were twice as many vessels registered as in the nineteen-thirties; at the same time commercial traffic rapidly decreased and by 1972 conveyed merchandise had dropped to little more than 4,000 tons. The decline in commercial traffic started in the mid nineteen-fifties, a time when merchandise was mainly coal and to a much lesser extent, timber, wheat and building materials. It was conveyed mainly from the tidal river through Teddington lock to Hampton Wick and other places as far as Staines, including the River Wey.

When registered pleasure vessels began to increase in the mid nineteen-fifties, passage through the locks was principally launches of which a large number were no more than thirty feet in length. The numbers of small craft passing through the locks were considerably less, and among these craft, dinghies, punts, canoes, sailing boats and skiffs were predominant. Looking at the fifty years (1948-97) during which the pattern of river traffic was changing, it can be seen (Appendix A) that the increase in registered pleasure vessels on the river reached a peak in 1973. There followed a period of gradual decline reaching a low point in 1983 followed by a slight recovery until 1990, which was the beginning of a rapid decline in the number of registered vessels and hence the number of passages through the locks. But the number of registered pleasure vessels did not correspond with the amount of activity on the river, and it was 1980 that saw the highest number of passages by pleasure traffic through the locks. Following this rise in acitivity a gradual decline took place and by about 1993 the number of passages through the locks had fallen by thirty-five per cent. Before reasons for this decline are sought, it is worthwhile examining the way the locks have been used during the period 1973-1997.[1] Appendix B shows the total number of lock cycles and total number of vessels conveyed through each lock. Not surprisingly, Marsh lock, just above Henley, had the highest traffic figure with Boulter's lock a close second. The graph shows

1. The numbers of vessels passing through each lock were not compiled for record purposes before 1973.

that the busiest part of the river was between Marsh and Boveney lock, while the least traffic recorded was between Lechlade and Oxford; the graph also shows there are no revelations about the way traffic moved between Lechlade and Teddington. The slightly improved figure at St John's lock was because of local boatyards that offered small craft for hire, and similarly in the region of Oxford where the population is very much greater resulting in higher traffic figures at King's, Godstow, Osney, and Iffley lock. At these locks the traffic figures were probably increased a little by narrow boats plying to and from the Oxford canal, and at the latter two locks, by the many pleasure craft from the lower reaches of the river that ended their journey at Oxford. The dominant traffic figure at Marsh lock is mainly because of the popularity of that part of the river, and partly to do with the Henley Royal Regatta, the Festival of Music and the Arts, and other regattas and events that attract many additional small craft to the reach between Marsh and Hambleden lock. Other locks are affected by the proximity of boatyards where small craft are available for hire on a daily basis. At the time river traffic was at its peak in 1980, boatyards flourished at Abingdon, Benson, Wargrave, Maidenhead, Chertsey, Sunbury, Thames Ditton and many other places; some are still operating, others have closed.

Seasonal variations in traffic passing through the locks has changed very little in recent times. The dominant months when pleasure traffic was at its peak are July and August, and with few exceptions the traffic figures were at their highest in August. The exceptions are at locks that handle the most traffic (Marsh, Hambleden and Hurley) where occasionally the figures for July exceeded those for August, mainly because the regattas and events already mentioned take place in July. Either side of these months the traffic figures were less for June and September with a further decline in April, May and October, though the figures for May were usually more buoyant. The dead months for traffic were January, February, November and December, with March only marginally better.

The near future is unlikely to see any change in terms of navigation on the river; the locks are well established and their adjoining weirs maintain control of the water in such a way that the needs of all parties using the river are satisfied. What then are the possible changes that could come about in the new millennium. Almost certainly advances in civil engineering will continue to influence the reconstruction of locks and weirs. The recently introduced underfloor filling systems will continue to be used and the reconstruction of locks will entail the use of different building materials, notably the introduction of steel mitre gates to replace the traditional wooden gates that use hard woods no longer available in the plentiful supply and quality of years gone by. It is hoped that maintaining the

traditions of the Thames locks will be a matter for careful consideration by the present administrators of the river, though a policy to retain the wooden balance beams as part of the lock gates on all the locks above Godstow is presently under review and may well signal the demise of the way the gates have been moved over more than three centuries.

One might project a little into the future and see the river between Lechlade and Teddington controlled by the most sophisticated technology. The present computer system that gathers data on water levels above and below each lock could become the brain that maintains water levels in all seasons by analysing the data and feeding back signals to the weirs to adjust water flow. It is also conceivable that just as now a garage door can be opened automatically from a car by using a radio-controlled signal, a similar arrangement could be adopted at a lock, requiring the navigator of a vessel to signal the lock as he approaches and for the lock to go through an automatic process of emptying or filling to give access to the vessel, and then to complete the cycle. But perhaps these are fanciful thoughts, even though they are entirely realistic in technological terms, with a form of automatic lock already in use on the inland waterways of France. While one should not brush such thoughts aside, the likelihood of their becoming reality is very slim. The control of the flow of the river is a complex and often demanding operation and its success depends very much on the human element. The work of the lock-keeper is not simply to fill and empty his lock, he must also be aware of the many environmental and other factors connected with the river in the immediate vicinity of his lock, including the operation of an adjoining weir and in some instances navigational hazards. It would seem therefore that the profession of lock-keeper is likely to remain unaltered during the foreseeable future of the river, as it is their experience and knowledge that is so important in maintaining the safe passage of traffic through the locks.

The administrations that followed the Conservators of the River Thames have been different only in name; their work is no more than an extension of the work of the Conservancy. But in one respect, lock and weir design has moved away from the one-time Conservancy's Chief Engineer to an in-house design and project management team who invite tenders from civil engineering contractors for major lock and weir reconstruction. More recent administrations have been increasingly concerned with environmental matters and particularly pollution, and the progress that has been made in improving the quality of Thames water has been particularly marked. It would seem, therefore, that the future of the river in navigable terms is assured. But an emerging pattern of change in the way the river is being

used is already apparent. The increase in registered pleasure vessels on the river has not been maintained following its rapid growth in the nineteen-sixties and seventies. And similarly, the number of passages by pleasure craft through the locks has fallen since the nineteen-seventies. The hire cruiser business aided this decline by at first creating more craft than were needed and then reducing the numbers in order to effect a more stable supply and demand situation.[1] Boatyards that were unable to accommodate this turnaround saw rich pickings from developers who wanted to buy boatyards for conversion to residential riverside housing, and not least, the cost of hiring a river cruiser began to convince would-be holiday makers that perhaps a relatively inexpensive trip abroad with almost guaranteed sunshine was a more attractive option. In addition, there is the wheel of fashion and it may be that as cruising on the Thames reached its peak in the nineteen-seventies and eighties, a time for change has come about. The attraction of cruising on the network of waterways in France must almost certainly be a factor and it is underlined by the rapidly increasing number of french hire craft bookings in recent years.

It is likely that a number of factors may hold the key to the future of the river; a declining trade in pleasure traffic and an increasing need to look at other ways of transporting goods as roads become increasingly congested, are two factors that could alter the face of river navigation in the new millennium. Unbelievable though it may seem today, the future may see a re-emergence of commercial traffic, though there are no signs of this at the moment. Even the broad canals of England have shown a decline in commercial traffic over the past ten years, a situation British Waterways would like to reverse. And this is understandable as canals and rivers continue to offer a viable means of transporting merchandise. Certainly the Thames is well equipped to handle a new breed of barge carrying non-essential cargoes, particularly as all restrictions to the efficient passage of river transport were removed long ago. It is not unreasonable to foresee the Thames in terms of an efficient waterway handling not only pleasure traffic but commercial traffic as well, and it is the present system of locking and water control that make this prediction feasible as a way forward for the future of the river.

1. Hire cruisers are used on average seven times more often than privately owned craft.

INDEX

APPENDICES